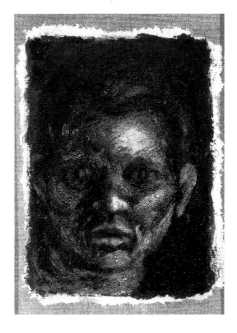

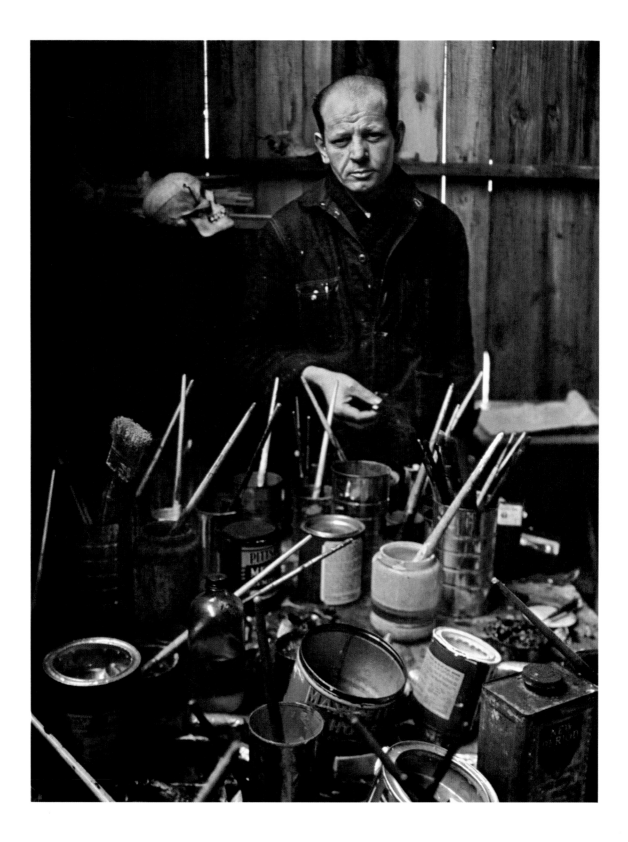

Leonhard Emmerling

JACKSON POLLOCK

1912–1956

TASCHEN

KÖLN LONDON LOS ANGELES MADRID PARIS TOKYO

© 2003 TASCHEN GmbH
Hohenzollernring 53, D–50672 Köln
www.taschen.com

© for the works of Jackson Pollock: Pollock-Krasner
Foundation / VG Bild-Kunst, Bonn 2003
© for the works of José Clemente Orozco, David Alfaro
Siqueiros, Stanley William Hayter and Hans Hofmann:
VG Bild-Kunst, Bonn 2003
© for the work of Pablo Picasso: Succession Picasso /
VG Bild-Kunst, Bonn 2003
© for the work of Thomas Benton Hart: T. H. Benton and
R. P. Benton Testamentary Trusts / VG Bild-Kunst, Bonn 2003
Translation from German by John William Gabriel
Project coordination: Juliane Steinbrecher, Cologne
Layout and editorial coordination: Daniela Kumor, Cologne
Cover design: Catinka Keul, Cologne

Printed in Germany
ISBN 3–8228–2132–2

Contents

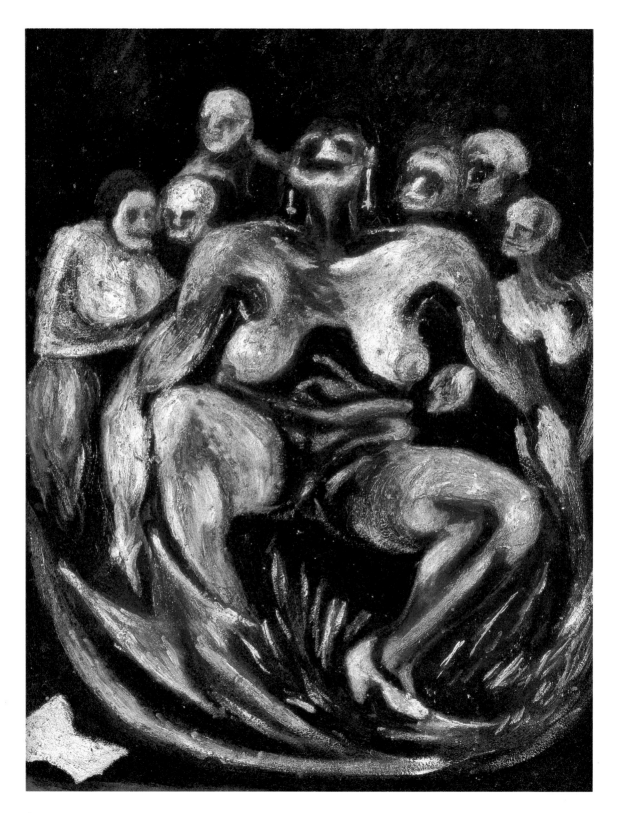

"An Artist of Some Kind…"

A man stands darkly silhouetted in front of a gray, clouded, empty surface leaning against the wall of a room (p. 7). His arms hang loosely by his sides; although his eyes are invisible, he seems to be looking directly into the camera. For over six months now, this man has been struggling with the task of painting a mural, nearly two-and-a-half meters high and over six meters long (8 x 19 feet), for the entry hall of a wealthy collector's house. The enormous canvas stands in his New York apartment, where a wall had to be torn out to accommodate it. Now, just after Christmas 1943, the time for procrastination has run out. The collector is planning a party, and she insists the canvas must be finished by that date. And so the artist plunges into his work and, in the course of a single night and morning, under incredible pressure, completes a painting that would mark a turning-point in twentieth-century art: *Mural* (pp. 8–9).

Out of the whirl of lines and colors, figures begin to congeal, elongated human shapes which, no sooner have we identified them, begin to dissolve again. Our eye glides from one reference point to the next without really ever being able to come to rest. Black lines, accentuated with yellow and green, flow into one another without forming actual contours, yet also without truly merging. After several attempts at a reading, heads, figures, feet and ground seem to appear in certain passages. Yet at the next attempt, this sense of solidity vanishes again. What remains is the impression of a clear rhythm, a logical and absolutely sure articulation of the picture plane. Yet rather than containing a center of interest, equal value is placed on every section of the image, which in turn creates an impression of virtual unboundedness.

This painting, done for the collector Peggy Guggenheim, was not anticipated by anything the American artist Jackson Pollock had done before. Comparable earlier works like *Untitled (Overall Composition)*, c. 1934–1938 (p. 10) or *The Flame*, c. 1934–1938 (p. 11), had the character of studies, or were still too much beholden to the subject matter that inspired them. The restless brushwork in the latter, for instance, derived from an effort to depict the flickering of a flame. *Mural* was different and remarkable in several respects.

It was the first work of Pollock's which both ignored human scale and was conceived to be viewed from close proximity. Monumental canvases by other artists, such as Claude Monet's *Water Lilies*, compel the viewer to step back and contemplate them from a distance. Like the other Impressionists and their suc-

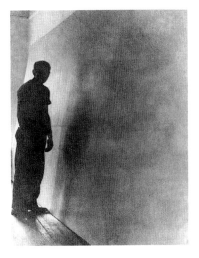

Jackson Pollock in his apartment at
46 Eighth Street, New York, with the
bare canvas for *Mural*, 1943
Photograph by Bernard Schardt
© Archives of American Art, Smithsonian
Institution

Untitled (Woman), 1935–1938
Oil on composition board, 35.8 x 26.6 cm
Kagoshima City (Japan), Nagashima Museum

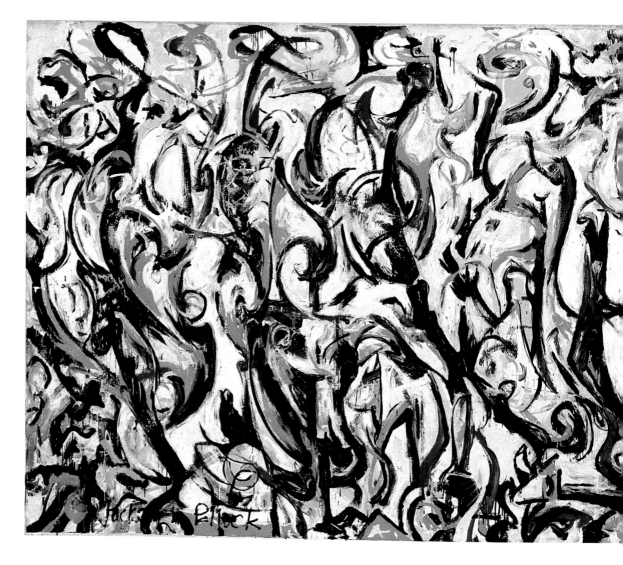

Mural, 1943/44
Oil on canvas, 247 x 605 cm
Iowa City, IA, The University of Iowa Museum
of Art. Gift of Peggy Guggenheim

Mural can be seen as a decisive turning point in Pollock's œuvre. It marks an abandonment of figuration in favor of the linear, gestural abstraction of the years 1947 to 1951.

cessors, the Pointillists and Divisionists, Monet designed his pictures to be seen from a certain distance, at which the separate brushstrokes and juxtapositions of colors merge in the eye into a motif and the overall composition becomes legible. Pollock's *Mural*, in contrast, invites close-up viewing. Although stepping back from it might permit us to gauge its overall dimensions, this provides no additional information about the image beyond that gained from a close-up viewing.

At the same time, this was the first work of Pollock's in connection with which – thanks to photography and later, film – the myth of the lone genius began retroactively to shape the aura surrounding the act of painting. Although there are no reports that would contradict the story of how *Mural* was done – Pollock indeed seems to have completed it in the space of single night and morning – from this point on, photography and film began to materially contribute to the image of an artist working intuitively, as it were directly from subconscious urges and physical memory. The photo of the painter standing alone, exhausted

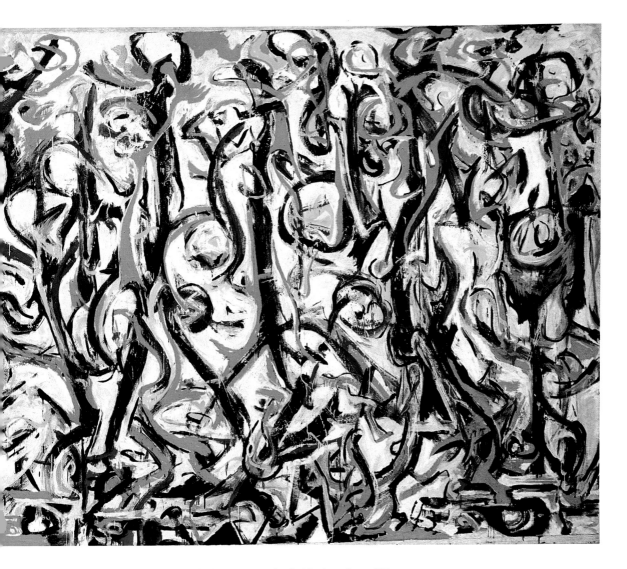

and phantom-like before his overwhelming, yet-to-be-finished work would become the quintessential image of the artist working on the verge of existential despair.

With *Mural*, Pollock, at the time little more than an unknown provincial artist trying to make his mark in New York, was suddenly catapulted into the first rank of international contemporary art. As Kirk Varnedoe notes, "Yet for a moment in January, when he put down the brush after the concentrated hours moving back and forth across the twenty feet of *Mural*, and painting from the floor to as high as his reach would stretch, this man stood alone at the head of the class, not just in New York but internationally. … There was nothing of this power and originality being made anywhere else in the war-plagued world that dim winter."

Paul Jackson Pollock was born on January 28, 1912, in the small town of Cody, Wyoming. He was the youngest of five sons, and the domestic circumstances of the Pollock family were anything but simple. The boy's personality was decisive-

ly shaped by a series of moves, his father's increasingly long absences, and his mother's dominant character.

At the age of fifteen, Jackson with his older brother Sanford spent the summer months with a party of land surveyors in the Grand Canyon. There, two of the older men introduced him to drinking. His later alcoholism, probably resulting in part from physical intolerance, would gravely exacerbate the psychological problems that grew out of his father's absence and his mother's coddling, and eventually necessitate several stays in psychiatric clinics and a series of therapies. Alcohol would also be to blame for Pollock's death, when, on the night of August 11, 1956, drunk, he smashed his car into a tree and died. With him perished Edith Metzger, an acquaintance of his then girlfriend, Ruth Klingman, who survived the accident.

Pollock's tendency to resist authority led more than once to his being expelled from school. In 1928 the family moved to Los Angeles, where Jackson attended Manual Arts High School. Here, too, he was an outsider whose dandified airs alienated his fellow students. He did find acceptance, however, from his art teacher, Frederick John de St. Vrain Schwankovsky. Schwankovsky took Pollock along to lectures by Krishnamurti, declared the new messiah by the Theosophical Society, to which thousands thronged. In May 1929, the two attended a

Untitled (Overall Composition), c. 1934–1938
Oil on canvas, 38.1 x 50.8 cm
Houston, TX, The Museum of Fine Arts;
Museum purchase

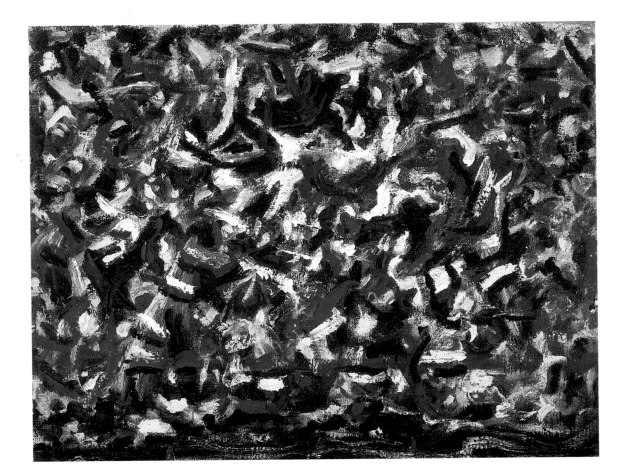

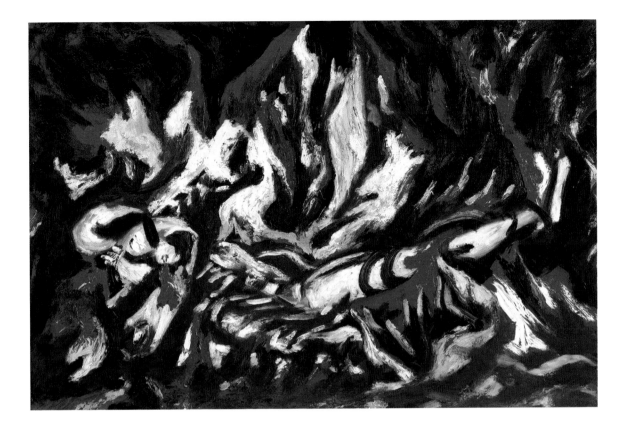

Krishnamurti summer camp in Ohai, California, where for a week they heard daily talks given by the Enlightened One. Years later Pollock would continue to underscore the strong influence exerted on him by theosophical ideas.

After that Pollock not only made further contacts in theosophical circles but among communists as well. It was likely they who introduced him to the idea that avant-garde art and radical politics belonged together. The same period also saw Pollock's incipient interest in the work of the Mexican muralists, José Clemente Orozco (1883–1949), Diego Rivera (1886–1957) and David Alfaro Siqueiros (1896–1974), all of whom emphasized the importance of the political function of art.

At Manual Arts the following year, Pollock took instruction in drawing and sculpture from Schwankovsky and the sculptor Harold Lehmann – but apparently without the slightest success. As he wrote to his brother Charles, "… my drawing i will tell you frankly is rotten it seems to lack freedom and rhythem it is cold and lifeless, it isn't worth the postage to send it. … altho i feel i will make an artist of some kind i have nver proven to myself nor any body else that i have it in me."

Both Jackson's oldest brother, Charles (1902–1998) and the fourth-born boy, Sanford LeRoy (1909–1963) – known as "Sande" –, had decided to pursue a career in art. Charles had gone to Los Angeles in 1921 to study at the Otis Art Institute, before transferring in 1926 to the Art Students League in New York. The Pollocks' third son, Frank (1907–1994), also moved to New York, in 1928. When Charles and Frank went to Los Angeles in June 1930, they took Jackson to

The Flame, c. 1934–1938
Oil on canvas, mounted on composition board, 51.1 x 76.2 cm
New York, The Museum of Modern Art, Enid A. Haupt Fund

To a certain extent, *The Flame* already exhibits Pollock's later tendency to linear, gestural abstraction. But here the agitated character of the lineature is still primarily intended referentially, to evoke the restless flickering of flames.

Albert Pinkham Ryder
Moonlight Marine, n.d.
Oil on wood, 29.2 x 30.5 cm
New York, The Metropolitan Museum of Art,
Samuel D. Lee Fund, 1934 (34.55)

see a mural by Clemente Orozco, *Prometheus*, at Pomona College in nearby Claremont.

It was Charles who, troubled by his youngest brother's precarious situation – Jackson was drinking heavily and increasingly subject to bouts of depression – suggested that he accompany Frank and him to New York. Jackson agreed, and enrolled there in a sculpture class at Greenwich House. He also joined a class at the Art Students League run by the painter Thomas Hart Benton (1889–1975), with whom Charles was already studying.

Benton, a representative of American Regionalism, vehemently rejected European modernism of every kind, above all Cubism, and oriented himself instead to ideals such as El Greco, Tintoretto or Rubens. Having spent time in Paris, Benton was quite familiar with developments in European painting, and, thanks to his friendship with the Synchromist Stanton Macdonald-Wright (1890–1973), with American experiments in abstract painting based on color harmonies and chords. Yet rejecting these without falling into a chauvinist provincialism, Benton developed a style based on strong plastic values, in which he rendered subjects related to the conquest of the West, but also to the life of its downtrodden original inhabitants, the Indians.

His interest in a "manly" painting led to a sinewy, muscular organization of the pictorial space (in Benton's own earthy language, "bumps and hollows"), as in *The Ballad of the Jealous Lover of Lone Green Valley* (p. 14 above), influenced by earlier art such as that of Lucca Signorelli. In addition, in 1919 Benton became aware of the experiments of Erhard Schön (1491–1542), a pupil of Dürer, and Luca Cambiaso (1527–1585), who broke down the human figure into a series of cubes as an aid to correctly depicting positions and movements. Pollock, too, employed this device in his sketchbooks down into the late 1930s (*Untitled, 1933–1938*, p. 14 below).

Benton befriended the young man from Cody, Wyoming. Although Pollock's posing as a cowboy dude put his fellow students off, it definitely attracted his teacher, who likewise played a role, that of a no-nonsense working man. Pollock's Wyoming background likely encouraged Benton to see him as a representative of that very American West he glorified in his art. He empathized with his student's machismo, as Pollock began to strut the big-city streets in cowboy boots and Stetson hat. Benton's attraction to Pollock seems to have had little to do with his skills in painting and drawing. As a fellow student sarcastically remarked, Pollock's draftsmanship was so poor that he would be better advised to go into tennis or plumbing. An insight into his state of mind at the time is provided by one of his earliest known works, a self-portrait that can be dated to between 1930 and 1933 (p. 1). The artist, just twenty or somewhat older, is hardly recognizable here. Out of a dark background gazes a neither masculine nor feminine face with large eyes and a tormented expression, at the same time childlike and prematurely aged.

At the time he painted this self-portrait, Pollock was deeply impressed by an outsider of American art, Albert Pinkham Ryder (1847–1917), who, despite his academic training, worked in complete isolation from the turn of the century to his death. Pollock's *T. P.'s Boat in Menemsha Pond*, c. 1934 (p. 13), was doubtless influenced by Ryder seascapes (p. 12), while his lithographs and paintings *Lone Rider*, c. 1934/35 and *Landscape with Rider II*, 1933 or *Going West*, c. 1934/35 (p. 15) reflect more of Benton's influence. The centrifugal composition, the anecdotal motif distorted to heighten its expressiveness, and the effort to create a sinewy, muscular plasticity – all of these features point to Benton.

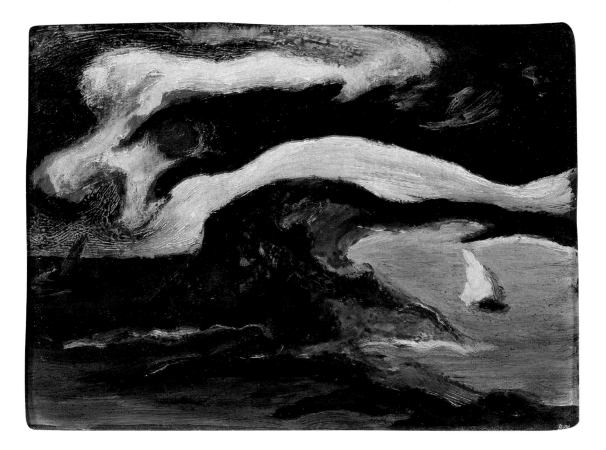

T. P.'s Boat in Menemsha Pond, c. 1934
Oil on metal panel, 11.7 x 16.2 cm
New Britain, CT, New Britain Museum of
American Art. Gift of Thomas H. Benton

Always restless and searching for motifs, Pollock repeatedly travelled to the Western states. His letters contain many descriptions of what befell him there, from poker games with black men and nights spent in jail to encounters with prostitutes. One can only speculate whether or not the picture of a female figure, *Untitled (Woman)* (p. 6), can be traced back to one such encounter. Surrounded by an eerie group of bald-headed, dwarflike figures emerging from the darkness, a woman crouches in the center with legs spread and eyes turned upwards. She is clad in nothing but pumps and earrings. With strong, almost masculine arms she reaches under herself to grasp something that might be a blanket or grass. The unpleasant effect of the depiction, the undercurrent of obscenity, and the idol-like heightening of the female figure, may well be associated with Pollock's relationship to his mother.

An overly indulgent woman who spoiled her youngest son, Stella Pollock instilled a lasting mixture of love and hate in Jackson. His brother Sande, in a letter to Charles, attributed Jackson's psychological problems to this relationship to their mother. In strangely detached words, as if speaking of some other family, Sande wrote, "Jackson is afflicted with a definate neurosis. Whether he comes through the normalcy and self-depency depends on many subtle factors and some obvious ones. Since part of his trouble (perhaps a large part) lies in his childhood relationships with his Mother in particular and family in general, it would be extremely trying and might be disastrous for him to see her at this

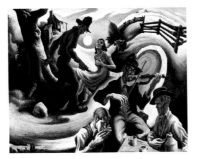

Thomas Hart Benton
The Ballad of the Jealous Lover of Lone Green Valley, 1934
Oil and tempera on canvas, transferred to aluminum panel, 106.7 x 134.6 cm
Lawrence, KS, University of Kansas, Collection of the Spencer Museum of Art

Untitled, 1933–1938
Pencil and colored pencil on paper,
45.7 x 30.5 cm
The Pollock-Krasner Foundation, Inc.,
New York

time." As late as 1956 Pollock himself emphasized how much he hated his mother, calling her "an old womb with a built-in tomb."

Pollock's emphasis on the muscular, also found in other female figures of the period, was probably influenced by the nudes of the Mexican muralist David Alfaro Siqueiros. Siqueiros and José Clemente Orozco were among the most significant politically committed artists of the day. Due to his radical politics Siqueiros was forced to leave Mexico in 1932 and went to Los Angeles. There, in the Italian Hall on Olvera Street, he executed a monumental mural entitled *La America Tropical*, an attack on the suppression of Latin America by the United States. (The painting was whitewashed over only a year after its completion, and was not rediscovered until the 1960s.) Pollock must have known this mural, since his brother Sanford worked as an assistant to Siqueiros in Los Angeles for a time. When the Mexican artist came to New York in 1936, Pollock participated in a workshop run by him.

The significance of Siqueiros for Pollock's further development, however, was less stylistic or iconographic than technical in nature. The Mexican painter encouraged workshop participants to experiment with industrial paints and lacquers, and add sand or other materials to enliven the picture surface. Even the pouring and dripping of paint which would later become Pollock's trademark and earn him the nickname "Jack the Dripper" was valued by Siqueiros – as a "controlled accident" which it was hoped would prompt more imaginative figurative solutions.

Even more strongly than Siqueiros, Pollock admired Orozco, who lived in the U.S. from 1927 to 1934. In the autumn of 1930 Orozco was working on a cycle of murals in the New School for Social Research, where Benton, too, had painted murals. In 1936 Pollock traveled with friends to New Hampshire, where from 1932 to 1934 Orozco had worked on the cycle *The Epic of American Civilization* at Dartmouth Collage, Hanover.

Apart from the direct effects the Mexican muralists exerted on his art, Pollock attached great importance to the mural form as such. For one thing, he entitled the work for Peggy Guggenheim mentioned at the outset *Mural*, despite the fact that it was painted on canvas. In the context of the Works Progress Administration (WPA) called into being by President Roosevelt to provide a modest income to artists by giving them public commissions, Pollock worked in the mural division before changing to the easel-painting division. More, he considered murals to be the medium of the future. In 1947, in an application for a Guggenheim fellowship, he wrote, "I believe the easel picture to be a dying form, and the tendency of modern feeling towards the wall picture or mural. I believe the time is not yet ripe for a full transition from easel to mural. The pictures I contemplate painting would constitute a halfway state, and an attempt to point out the direction of the future, without arriving there completely."

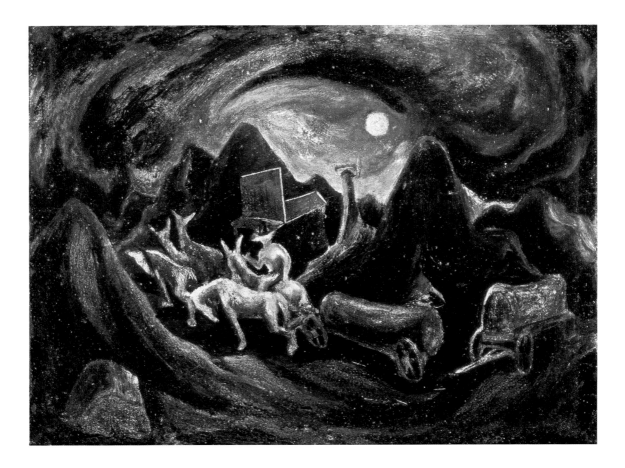

Going West, c. 1934/35
Oil on fiberboard, 38.3 x 52.7 cm
Washington, DC, National Museum, Smithsonian Institution.
Gift of Thomas Hart Benton

Going West is one of the many paintings in which Pollock
combined typically American themes such as the pioneer and
lonesome cowboy with the personal experiences he had
on trips through the Western states.

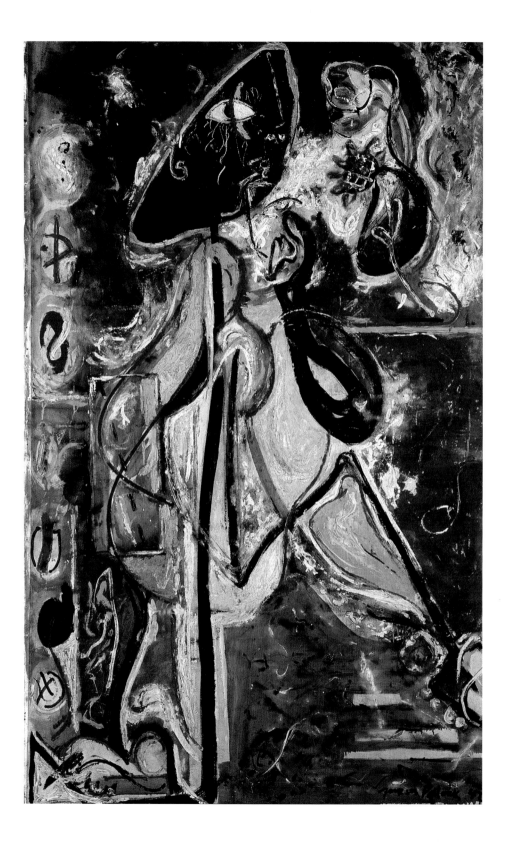

Ideals and Influences

Pollock's alcholism led at the turn of the year 1937/38 to a four-month stay in a psychiatric hospital. In January 1937, he entered therapy for the first time, with the psychiatrist Joseph L. Henderson. Henderson was a follower of the Swiss psychoanalyst Carl Gustav Jung (1875–1961). In contrast to his teacher Sigmund Freud, whose doctrines had influenced the French Surrealists, Jung believed the contents of the unconscious mind went beyond repressed libidinous affects. Jung posited the existence of what he called the "collective unconscious," a treasure trove of archetypal visual imagery common to all human beings, whose encrypted meaning it was the psychoanalyst's task to decipher.

Since Pollock always had trouble describing his personal situation verbally, he soon began bringing pages from his sketchbooks to the therapy sessions and giving them as presents to Henderson. These subsequently became famous as his "Psychoanalytic Drawings." Yet the title is misleading, because the works were done not during the sessions but entirely independently of them. The drawings are so diverse in terms both of form and content that the only justification for viewing them as a group would seem to be their origin in Henderson's collection.

Generally speaking, the dominating influence on Pollock's art at this period came from Orozco. The effect of his Hanover murals is clearly evident in the sketch *Untitled* (p. 17), from the Henderson collection. In Orozco's *Gods of the Modern World* (p. 18), several skeletons in academic gowns stand around a human skeleton lying in front of them, out of whose abdomen one of the academics pulls a skeletal foetus. Books and specimen jars underscore the message: the depravity of cold, Western knowledge and the diastrous consequences of colonization.

The skeleton reappears in Pollock's sketches, overarched by what appear to be two semi-abstract figures consisting of concave and convex shapes that merge at head height. The drawing can also be linked with the oil *Untitled (Woman with Skeleton)*, c. 1938–1941 (p. 19). Orozco's drastic imagery and his Michelangelesque emphasis on muscularity, as seen in the preparatory painting for *The Two Natures of Man*, reappear in Pollock's *Untitled (Naked Man with Knife)*, c. 1938–1940 (p. 20), a conglomeration of prismatic and rounded shapes that fill the entire picture field. Visible at the right edge is a male figure holding a dagger in both hands and about to plunge it into his victims. These, apparently, are several

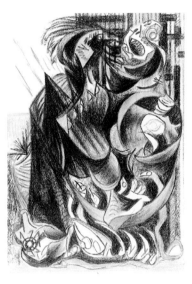

Untitled, 1938/39
Colored pencil on paper, 38.1 x 28 cm
Carmichael, CA, Collection Mr. & Mrs. Aichele

The Moon-Woman, 1942
Oil on canvas, 175.2 x 109.3 cm
Private collection

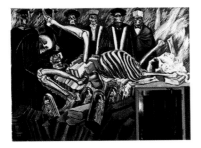

José Clemente Orozco
Gods of the Modern World, panel 12 of *The Epic of American Civilization*, 1932–1934
Fresco mural
Hanover, NH, commissioned by the Trustees of Dartmouth College

human beings, judging by the clawlike hands, the arms and thighs which are all that is recognizable. The impression of force and violence is augmented by the swirling forms, and the dagger point is repeated in the triangular shape in the lower section of the image.

In connection with the drawings owned by Henderson, there has been much discussion about whether or not Pollock consciously reacted in them to Jungian psychology and, as it were, illustrated its contents. In fact there was only a single drawing, since lost, that clearly indicated Pollock's involvement with Jung's ideas (p. 23). That Pollock was familiar with them in general can be safely assumed. One indication is the frequent association in his work of moon with woman, as in *The Moon-Woman* (p. 16), *The Mad Moon-Woman* and *The Moon-Woman Cuts the Circle* (p. 21), images that were probably derived from Esther Harding's *Woman's Mysteries*. In this book, which Pollock is known to have owned, the author devoted detailed discussion to certain aspects of Jungian iconography. And as his friend Alfonso Ossorio (1916–1990) reported, in the rare cases when Pollock talked about works of art, he used psychoanalytical terms more frequently than aesthetic ones.

Still, Pollock's figurative drawings and paintings can neither be read as illustrations of psychoanalytic concepts, nor can they be said to supply psychologically valid insights into his state of mind. Jung's doctrine of archetypes likely had no greater influence on Pollock than it had on his contemporaries. The analyst's teachings were seen as holding the promise that by recurring to archetypal symbols, artists could gain access to a repertoire of imagery that was common to all human beings beyond cultural and racial boundaries, and was therefore of equal value and immediately understandable to all. To a considerably greater degree than Freud's much more individually oriented theories of the libido, Jung's depth psychology seemed to provide an opportunity to create a universally understandable, humane art.

This hope nourished by the Jungian doctrine of archetypes was later combined in Pollock's mind with automatism, as practiced by the Surrealists. Yet during the period of his therapy, it was above all the art of the indigenous American peoples in which he sought models for an art that would be independent of Europe, truly American, and, through recourse to Jungian archetypes, comprehensible to all.

In 1943 Pollock stated in an interview, "I have always been very impressed with the plastic qualities of American Indian art. The Indians have the true painter's approach in their capacities to get hold of appropriate images, and in their understanding of what constitutes painterly subject-matter. Their color is essentially Western, their vision has the basic universality of all real art. Some people find references to American Indian art and calligraphy in parts of my pictures. That wasn't intentional; [it] probably was the result of early memories and enthusiasms."

Pollock had been acquainted with Indian art from his early youth. During one of several visits to the exhibition "Indian Art of the United States," held at the Museum of Modern Art in New York from January 22 to April 27, 1941, he watched Navajo artists making sand paintings on the floor. An interest in so-called primitive art was one that Pollock shared with many other painters. As Mark Rothko, whose devotion to Abstract Expressionism would later be recorded in the famous photograph of "The Irascibles" (p. 95), once observed, "archaic art and mythology contained eternal symbols … of man's primitive fears and motivations. … And our modern psychology finds them persisting still in our

dreams, our vernacular and our art, for all the changes in the outward conditions of life."

The focus of interest had now shifted from the Oceanic or African art that had fascinated the Cubists and German Expressionists to American Indian art. This was one indication of the attempts of young American artists to find ways of constructing a non-European, American genealogy, and thus a truly American identity. Still, Pollock rejected the notion of an "American art": "The idea of an isolated American painting, so popular in this country during the 'thirties, seems absurd to me, just as the idea of creating a purely American mathematics or physics would seem absurd. ... An American is an American and his painting would naturally be qualified by that fact, whether he wills it or not. But the basic problems of contemporary painting are independent of any one country."

Still, American artists felt challenged to break the dominance of the many European painters and artists who had emigrated to the U.S. before the Second World War. The struggle to find a personal visual language, perfectly exemplified by Pollock's involvement with Picasso, was not only a young artist's struggle with some overweening father figure. It was also a struggle to develop an autonomous form of art which, if were to be authentic, had to liberate itself from every historical legacy. Navajo sand paintings and Indian totem cults seemed to be formally and substantially unspoiled models, and adapting them promised a certain degree of independence from the all-powerful European painting tradition.

Untitled (Woman with Skeleton), c. 1938–1941
Oil on wood, 50.8 x 61 cm
The Pollock-Krasner Foundation, Inc. Courtesy Washburn Gallery, New York

Many of Pollock's depictions of women, including *Untitled (Woman with Skeleton)*, convey an oppressive and frightening image of the female as dominant and overweening. They reflect the artist's difficult relationship with his mother, a deep and ambivalent tie he would never overcome. In stylistic terms, the present work goes back to the influence of the Mexican muralist Orozco.

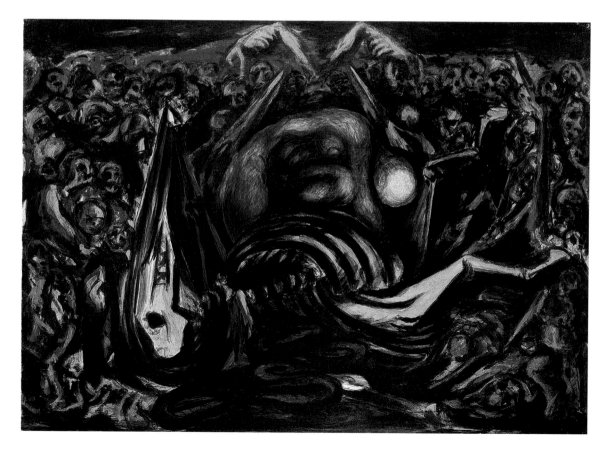

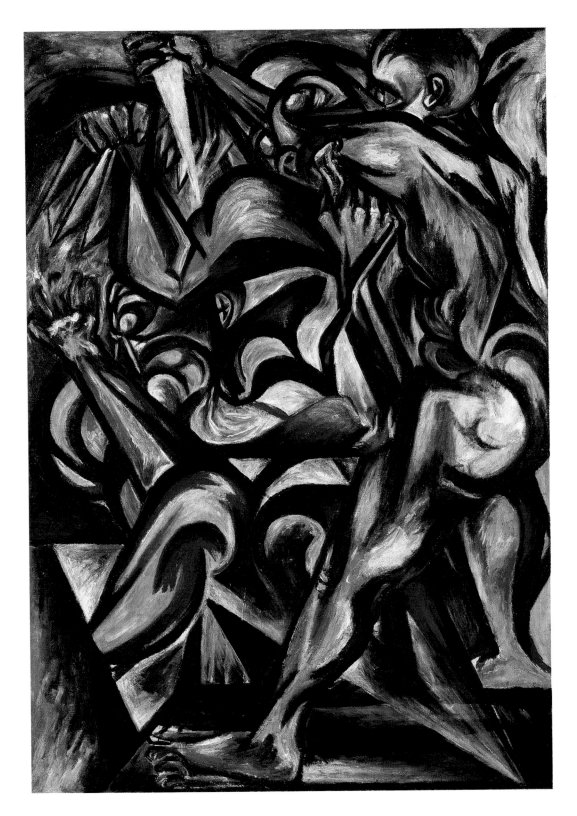

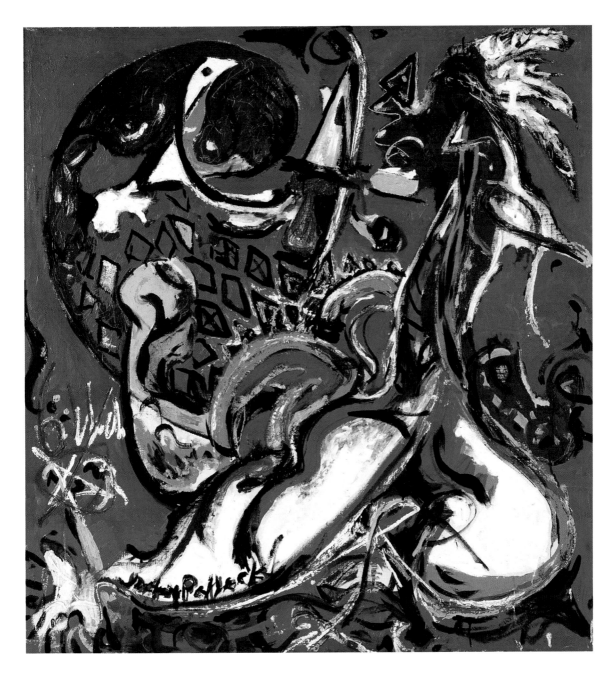

The Moon-Woman Cuts the Circle, c. 1943
Oil on canvas, 109.5 x 104 cm
Paris, Musée National d'Art Moderne,
Centre Georges Pompidou

PAGE 20:
Untitled (Naked Man with Knife), c. 1938–1940
Oil on canvas, 127 x 91.4 cm
London, Tate Gallery

Untitled, c. 1939/40
Pencil and colored pencil on paper,
35.5 x 27.9 cm
Nashville, TN, Collection Leonard Nathanson

Untitled (Dancing Shaman), 1939/40
Colored pencil on paper, 38.1 x 27.9 cm
Private collection

The motif of the shaman played a key role in
Pollock's early work. The shaman figure embo-
died hope in a unification of the human and
animal realms, and a general reconciliation of
man and nature.

Pollock's belief that the problems of contemporary art had nothing to do with
the artist's nationality was confirmed by the interest in American Indian art
shown, for instance, by Max Ernst (1891–1976) and André Masson (1896–1987)
after arriving in America, as well as the influence later exerted by Pollock's own
art on French Tachism and German Art Informel. In fact, he was never concern-
ed with developing a specifically American painting. Pollock's aim was to express
the times he lived in: "It seems to me that the modern painter cannot express this
age, the airplane, the atom bomb, the radio, in the old form of the Renaissance or
of any other past culture. Each age finds its own technique. ... The modern art-
ist, it seems to me, is working and expressing an inner world – in other words –
expressing the energy, the motion, and other inner forces. ... The modern artist
is working with space and time, and expressing his feelings rather than illustrat-
ing."

So in Pollock's view, modern artists did two things: first, they reflected the
conditions of their era by using new, unusual techniques; and second, they gave
immediate expression to their emotions rather than merely illustrating them.
Added to this, we have the factors of space and time, which came to be reflected

in the significance Pollock attached to the format of his works and his technique of Action Painting.

Pollock formulated his statements with very precise intentions. Regardless of whether one believes his works truly reflected the period or were adequate images of the atomic age, there is no gainsaying the fact that Pollock's intention was to develop not so much a truly American, but a truly contemporary style of painting. It was only posthumously, based on the films and photographs showing him at work, and only by reference to his origins and fragile mental constitution that he was stylized into an "American Prometheus" and praised as the inventor of a genuinely American art. The issue of a genuinely American art was an issue of reception and American cultural policy; it was certainly no great concern of Pollock's.

Significantly, almost all the artists associated with American Abstract Expressionism involved not Freud but Jung and his doctrine of archetypes. In Pollock's case, an interest in Jung was augmented by a fascination with imagery in which an animistic connection between man and animal played a role. In this respect as well, links with the art of the Northern and Central American Indians were of great moment. From the beginning, Pollock – like Beuys at a later date – was intrigued by the role of the shaman, who mediated between the animal and human realms and suffered through a grave, nearly fatal illness from which he emerged illuminated, enabling him to establish contact between the two realms and to convey the resulting superhuman wisdom to those around him. The Jungian theory that the shaman passed through one or more cycles of birth, death and rebirth, was one of the many aspects of Jung's psychology which Pollock's therapists are known to have discussed with him.

Pollock created an embodiment of the shaman figure in *Naked Man*, c. 1938–1941 (p. 23), a male figure with a feather mask in his right hand and a face represented by a rounded form derived from one of the eagle depictions of the Northwest Indians. The shaman also played a role in the drawings Pollock gave to Henderson (p. 22 below). And as Pollock reputedly told Violet Staub de Lazio, the psychotherapist who replaced Henderson when he left New York in 1940, he himself was in search of the source of power from which shamans' visions derived. *Masqued Image* and *Birth* (p. 24), both dating to 1938–1941, with their vortex of barely identifiable forms, still evince a reliance on Benton's principle of centrifugal composition. Yet in terms of subject matter, they not only show an adaptation of the shaman's dance but quote the totem depictions from Orozco's *Epic of American Civilization* and an Eskimo mask, based on an illustration Pollock found in a magazine. In addition, the rough surface indicates the influence of Navajo sand paintings.

Birth was included in the first exhibition in which Pollock participated: "American and French Painting" (January 20 to February 6, 1942). It was curated by the painter and writer John D. Graham (1881–1961), who encouraged Pollock's involvement with Picasso – an involvement that would prove as fruitful as it was paralyzing. In *Birth*, which at first glance does not recall Picasso at all, the lower leg shape recalls the leg position of the masked figure in *Les Demoiselles d'Avignon*, Picasso's revolutionary 1907 painting now in the Museum of Modern Art. Picasso's masterpiece *Guernica* (p. 25) was on exhibit in 1939 at the Valentine Gallery in New York, and in 1940 the Museum of Modern Art organized the exhibition "Picasso: Forty Years of His Art." In other words, there was ample opportunity for Pollock to familiarize himself with the Spaniard's work in the original. The impact of the mural-like *Guernica*, Picasso's reaction to the Fascist bom-

Naked Man, c. 1938–1941
Oil on plywood, 127 x 61 cm
Private collection

Untitled, 1938/39
Pencil on paper
Whereabouts unknown

Birth, c. 1938–1941
Oil on canvas, 116.4 x 55.1 cm
London, Tate Gallery

The rough surface treatment of *Birth* clearly reflects the influence of Navajo sand paintings. In his search for non-European models for a new American painting, Pollock took a major interest in the art of indigenous American peoples, including the Eskimos.

bardment of the Spanish town of that name on April 27, 1937, is especially evident in a number of Pollock's sketches. Although *Orange Head*, c. 1938–1941 (p. 27), is generally considered to represent the culmination of this two-edged fascination, despite its mixture of frontal and profile views it does not reflect Pollock's involvement with Picasso as clearly as many other sketches. In one of these (p. 28 above right) we see several faces with mouths open in a scream, that at the lower right obviously inspired by the raised head of the figure at the right edge of *Guernica*. The dagger-like tongue of the motif resembling a bull's head at the left edge, seems to echo the similar device found in both the finished painting and Picasso's preliminary studies for it. The bull at the upper left edge is likewise clearly a reference to Picasso, who delineated his alter ego in the form of a bull, or rather a hybrid creature, part bull, part human.

The group of Henderson drawings contains numerous indicators of the great significance that Picasso's work held for Pollock. The head in *Untitled* (p. 28 above left), for instance, recalls depictions of heads in Picasso's "bone period," while the steer in *Untitled* (p. 26) goes directly back to Guernica. Pollock subjected further Picasso adaptations to characteristic transformations. The terrifying appearance of the double head (p. 28 below) is as little thinkable without Picasso as is another head from the same group of drawings (p. 29). Yet the addition of feather headdresses and protruding tongues, suggesting a blend of human and animal head – perhaps that of a horse – lends Pollock's depictions an animistic aspect which we do not find in this form in Picasso. Picasso's man-animal combinations, such as the Minotaur, derive from Greek mythology, whereas Pollock's hybrids go back to different sources, namely shamanistic and animistic ideas. So although the faces in *Untitled* (p. 22 above) may have been inspired by heads from Picasso's neoclassical period, the mixture of female and male gender, animal, floral and human elements goes beyond a mere appropriation of an existing pattern.

Picasso's influence, along with that of Joan Miró (1893–1983) and, less strongly, that of Paul Klee (1879–1940), would prove the key motor, and at the same time the greatest obstacle, to Pollock's development up to the turning point of *Mural*. How strongly Picasso's innovations set limits on what Pollock believed he

Pablo Picasso
Guernica, 1937
Oil on canvas, 349.3 x 776.6 cm
Madrid, Centro de Arte Reina Sofía

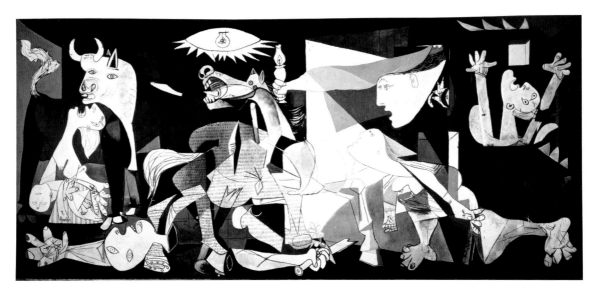

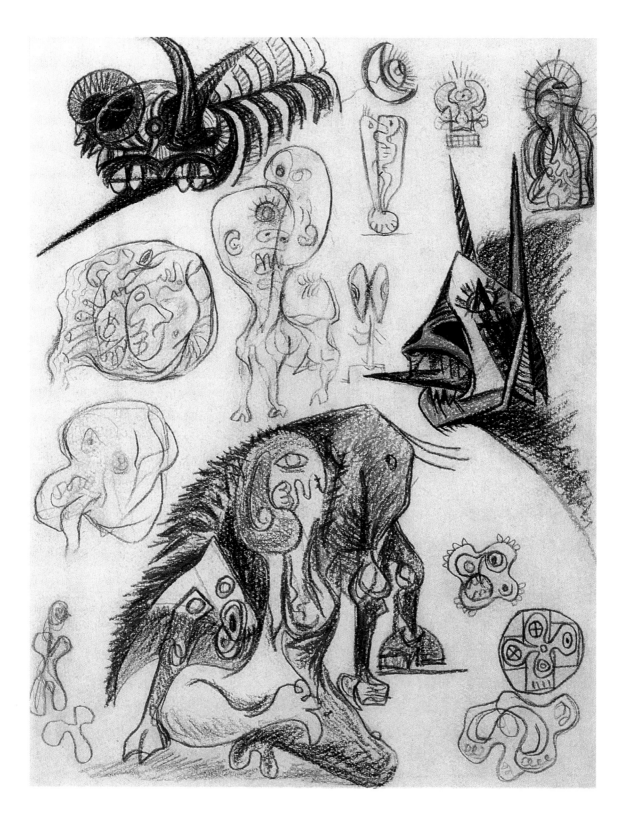

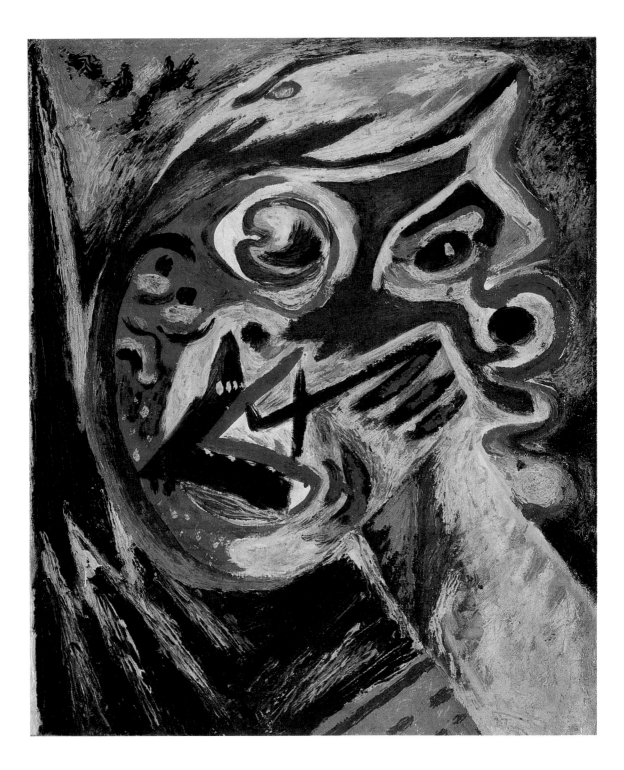

Untitled, 1938/39
Colored pencil on paper, 22.1 x 20.9 cm
Whereabouts unknown

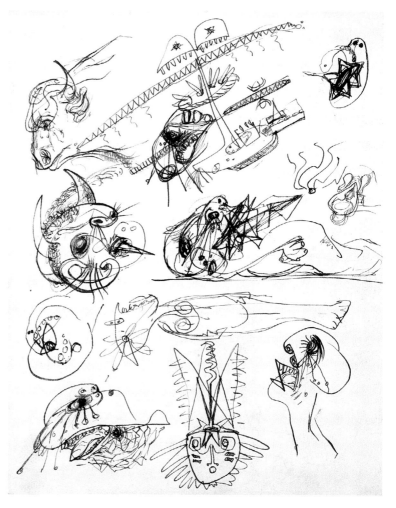

Untitled (Sheed of studies), c. 1939–1942
Pen and ink, colored pencil on paper,
33 x 26 cm
New York, The Metropolitan Museum of Art.
Gift of Lee Krasner Pollock, 1982 (1982.147.12b)

Untitled, 1938/39
Pencil and colored pencil on paper,
15.2 x 17.1 cm
Collection Robert E. Abrams

was capable of achieving, is indicated by the report of a temper tantrum, when
Pollock threw a book about Picasso's art on the floor, screaming, "God damn it,
that guy missed nothing!"

In an exhibition entitled "American and French Painting," John D. Graham
confronted works by the unknown New York artist with a few by the over-
whelming Spaniard. Also represented there was a young woman artist, a student
of the expatriate German painter Hans Hofmann (1880–1966) who had already
gained a name for herself on the art scene. This was Lee Krasner, and when she
found the unfamiliar name Jackson Pollock on the list of exhibiting artists, she
decided to pay him a visit. From that point on Krasner, an artist of considerable
skill who at the time enjoyed a much greater reputation than Pollock, would al-
ways stand in the shadow of the man whom she wed on October 25, 1945, and
whose career she decisively furthered.

Along with the artist and art historian Robert Motherwell (1915–1991),
Pollock and Krasner took part in various meetings at the studio of Roberto
Matta Echaurren (1911–2002). Close analogies to Matta's style, which combined

Untitled, 1938/39
Pencil and colored pencil on paper,
15.2 x 18.2 cm
Albuquerque, NM, University of New Mexico

William Baziotes, Gerome Kamrowski and
Jackson Pollock
Untitled, 1940/41
Oil and enamel on canvas, 48.9 x 64.8 cm
Collection Mary Jane Kamrowski

In this collaborative work, done on a whim, the
three painters employed the technique of drip-
ping and pouring as a matter of course. They
were all quite familiar with such methods, from
which we may infer that Pollock's significance
for the history of painting does not inhere solely
in his employment of them.

PAGE 31 ABOVE:
Landscape with Steer, 1935–1937
Lithography with airbrush, 34.6 x 47 cm
New York, The Museum of Modern Art.
Gift of Lee Krasner Pollock

smooth surfaces with surprisingly plastic forms, are found in one of Pollock's
few lithographs, *Landscape with Steer*, 1935–1937 (p. 31). Although clearly done
before meeting Matta, this work may explain why Pollock apparently felt the
exiled Surrealist to be a kindred spirit. As far as technique is concerned, the
lithograph was influenced by Siqueiros, as was the painting *Untitled*, 1944 (?),
which Pollock gave to the critic Clement Greenberg as a wedding present in 1956
and which he claimed was done in 1939 (pp. 32–33). In addition to gestural and
tactile passages, the picture contains figurative allusions and evinces an overall
effect so similar to Siqueiros's *Collective Suicide*, 1936 (p. 31 below), that an influ-
ence on the part of Pollock's teacher at the Laboratory of Modern Techniques in
Art would seem more than probable.

Even though he refused to acknowledge association with any group, Pollock
was intrigued by the idea of Surrealist automatism, by means of which the con-
trol of the conscious mind could be bypassed in order to directly tap the imag-
ery of the unconscious, thought to be the source of all true art. In 1944 Pollock
stated, "I am particularly impressed with their [the Surrealists'] concept of the
source of art being the unconscious. This idea interests me more than these spe-
cific painters do, for the two artists I admire most, Picasso and Miró, are still
abroad."

Shortly before Pollock met Matta, a work emerged (p. 30) that is remarkable in two respects. It is the only collaborative work in Pollock's œuvre, and in addition it proves that throwing paint at the canvas was a common procedure among his colleagues as well. Together with Pollock, the painter William Baziotes (1912–1963) and the sculptor Gerôme Kamrowski (b. 1914), who, like Lee Krasner, was a student of Hans Hofmann, decided on a whim to develop a canvas that had been spattered with various colors. One after another, the three artists began to sling paint on the image with a palette knife, and Kamrowski recalled the intensity and concentration with which Pollock worked. It is not recorded whether any of the three artists considered this technique remarkable or in any way out of the ordinary.

David Alfaro Siqueiros
Collective Suicide, 1936
Duco on wood with applied sections,
124.5 x 182.9 cm
New York, The Museum of Modern Art.
Gift of Dr. Gregory Zilboorg

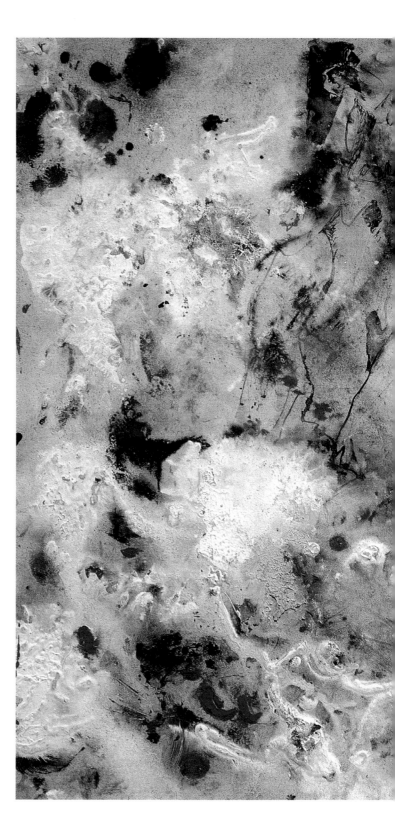

Untitled, 1944 (?)
Mixed media on cardboard, 36.2 x 48.9 cm
Collection of Mr. and Mrs. Christian Fayt

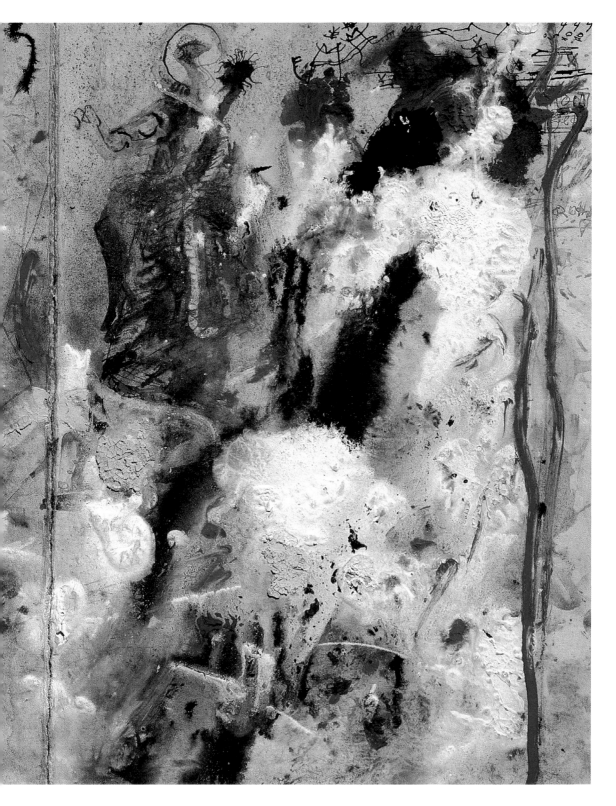

Male and Female

Although he worked feverishly through the years 1942 and 1943, Pollock's precarious financial situation did not show much improvement. Since August 1942 he had been sharing a small apartment on Eighth Street with Lee Krasner, and at the beginning of that year, promising contacts had begun to develop with Peggy Guggenheim (1898–1979), a niece of Solomon R. Guggenheim and one of the foremost collectors of Classical Modern, Surrealist and contemporary art. After arriving in New York from London in 1941 with her family and Max Ernst (whom she would soon marry), she rapidly opened a gallery, Art of This Century, which she described as a "research laboratory for new ideas." The gallery, extravagantly designed by the Austrian architect Frederick Kiesler (1890–1965) (p. 35), caused a sensation. Guggenheim was also adept at attracting renowned advisors. One of the most significant was James Johnson Sweeney, later director of The Solomon R. Guggenheim Museum, who in 1944 was instrumental in having Pollock's painting *The She-Wolf* (p. 42) purchased by the Museum of Modern Art – his first museum acquisition ever.

Yet despite Sweeney's encouragement, Peggy Guggenheim initially hesitated to pay Pollock a visit. She wanted to wait for Marcel Duchamp's opinion before approaching the young unknown painter. In the meantime Pollock was keeping his head above water by cleaning rollers at the Creative Printmakers studio on Eighteenth Street and working as a watchman at the Museum for Non-Objective Painting. In 1952 this museum would be rechristened The Solomon R. Guggenheim Museum and in 1959, achieve world renown thanks to its new building designed by Frank Lloyd Wright.

Whether Pollock's relationship with Lee Krasner motivated the moon-woman pictures mentioned above, can only be speculated on. We do know that both of them had a penchant for the moon, and that, after moving in 1945 into their new house on Long Island, The Springs, they spent nights silently gazing at the moon. In all probability, however, a link did exist between the painting *Male and Female*, c. 1942 (p. 34) and Pollock's steady relationship, which was something new for him. The coalescence of anima and animus, female and male, played a key role in the Jungian typology, so this picture has inspired any number of psychological interpretations, despite the fact that it is unclear which of the two figures is female and which male. For instance, the left-hand figure has been read as male, due to the curved red shape dangling like a limp penis from its midpoint,

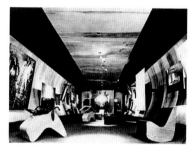

Frederick Kiesler's design for Peggy Guggenheim's gallery Art of This Century, Surrealist Gallery, New York 1942.
Photograph by Berenice Abbott
© The Solomon R. Guggenheim Foundation, New York.
Courtesy of Austrian Frederick and Lillian Kiesler Private Foundation

Male and Female, c. 1942
Oil on canvas, 186 x 124.3 cm
Philadelphia, PA, Philadelphia Museum of Art.
Gift of Mr. and Mrs. H. Gates Lloyd, 1974

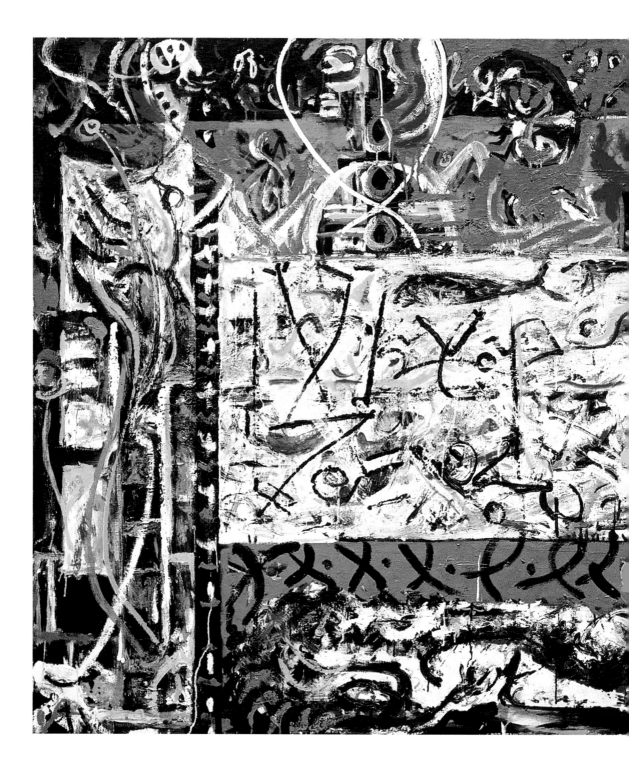

Guardians of the Secret, 1943
Oil on canvas, 123 x 192 cm
San Francisco, CA, San Francisco Museum
of Art, Albert M. Bender Collection

In *Guardians of the Secret*, Pollock makes reference to the theosophical doctrine of the "guardians of the threshold," which he knew through lectures by Krishnamurti. By complicating and purposely veiling the imagery in many paintings of this period he attempted to invoke a magical, metaphysical reality.

Blue (Moby Dick), c. 1943
Gouache and ink on composition board,
47.6 x 60.6 cm
Kurashiki (Japan), Ohara Museum of Art

and the right-hand one as female, based on the yellow triangle in the pubic area (colors supposedly motivated by Jungian color iconography). Yet it would be equally justified to describe the left-hand figure as female, due to the long eye-lashes and the form at breast-height emphasized in blue. Such characteristic traits are not present in the right-hand figure, even though the whitish-blue con-figuration has been interpreted as an ejaculation, which might permit a gender identification.

Interestingly, a Picasso painting that is formally very similar to *Male and Female*, *The Kiss*, 1925, shows a man with long eyelashes and evinces a diamond pattern which psychoanalytically oriented commentators have read as a symbol of fertility. This pattern also occurs in another Picasso, *Girl in Front of a Mirror*, 1932, a work in the collection of the Museum of Modern Art which Pollock surely knew. If Pollock in fact made reference to Jung's animus-anima concept in his painting, it very likely involved avoiding any specific gender orientation and un-derscoring the components of the opposite sex in each of the two figures.

A concern with mythical themes remained dominant in Pollock's work down into the early 1940s. The title of *Guardians of the Secret* (pp. 36–37) relates to the theosophical conception of "guardians of the threshold," with which Jackson Pollock probably became acquainted at the period of his enthrallment with

Krishnamurti. The large-format canvas features two military-looking figures at the edges, flanking a white-grounded rectangle on which, when the picture is turned upside down, one sees stick-figures like those that appeared in Pollock's sketchbooks, possibly inspired by Klee. Below the rectangle rests a doglike animal, probably representing a further "guardian." What secret the two figures and dog are guarding, remains unclear. Pollock's tendency to cryptic and occult subject matter that invokes an enigmatic, archetypal superreality, precludes any clear legibility of content a priori. So it comes as no surprise that many of the symbols on the central rectangle, which probably represent the secret in question, were probably borrowed from the *Fourth Book of Occult Philosophy* by the Renaissance mystic Agrippa von Nettesheim (1486–1535), which Pollock knew from a two-page reprint in the February–March 1942 issue of the magazine *View*.

Guardian-like figures also appear at the edges of the painting *Pasiphaë*, 1943 (pp. 40–41), whose title was not Pollock's but was suggested by Sweeney. Between the two guardians turning toward the center of the picture extends a reclining figure with outsized hands and feet. The lower area of a drawing done at the same period shows a woman, reclining on an animal, whose arms are thrown backwards as if in pain or ecstasy. Although the analogy with the central

Red and Blue, c. 1943–1946
Gouache, tempera and ink on composition board, 48.6 x 61 cm
Collection Charles H. Carpenter Jr.

PAGES 40–41:
Pasiphaë, 1943
Oil on canvas, 142.6 x 243.8 cm
New York, The Metropolitan Museum of Art. Purchase, Rogers, Fletcher and Harris Brisbane Dick Funds and Joseph Pulitzer Bequest, 1982 (1982.20)

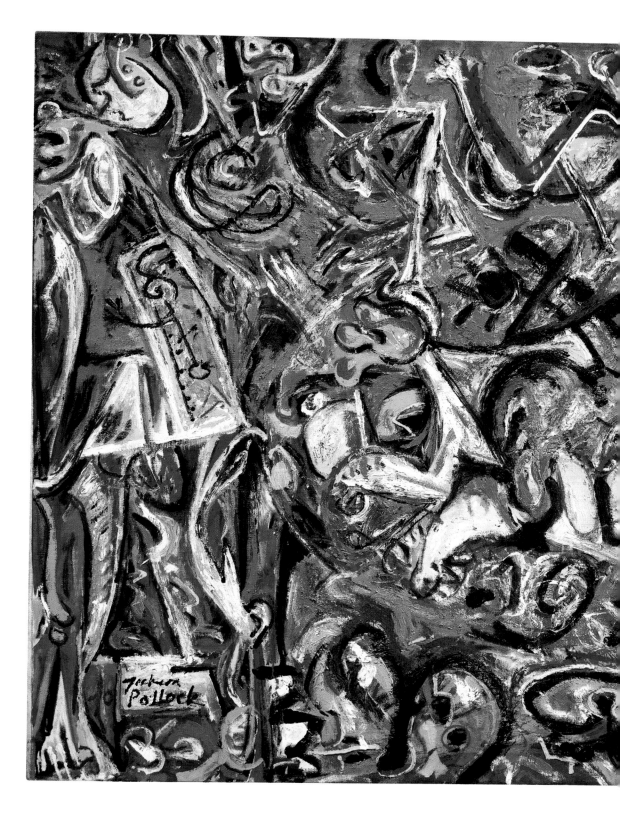

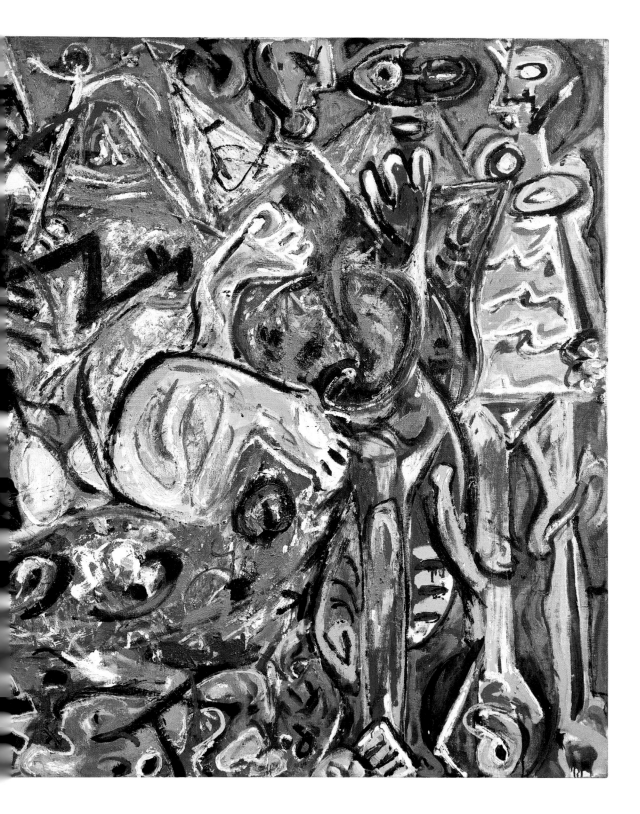

figure in *Pasiphaë* is evident, here the oval blue configuration around the figure suggests a kind of bed or table rather than an animal, and the figure's female gender is anything but clear. When he saw it in the artist's studio, Sweeney may have overhastily read the image, perhaps associating it with a painting of the same title by André Masson. According to Lee Krasner, Pollock was not even acquainted with the myth of the wife of the Cretan king, Minos, who fell in love with a bull, mated with him in the guise of a wooden cow, and gave birth to the Minotaur. Krasner reports that when Sweeney suggested the title, Pollock merely asked, "Who the hell is Pasiphaë?" Hence wariness is in order regarding many of the anecdotal, mythological or merely narrative titles of Pollock's paintings. A great proportion of them were not the artist's own but were frequently suggested by his wife or friends. The titles turn interpretation in directions that were likely unintended by Pollock.

In the early 1940s Pollock began experimenting with ever new configurations and techniques. This is well illustrated by a comparison between *Pasiphaë* and the canvas *Blue (Moby Dick)*, c. 1943 (p. 38). The expressive, apparently rapid, non-objective paint application that obscures the figure-ground relationship in *Pasiphaë* gives way in *Blue* to an economical, restrained composition that combines a neutral blue ground with abbreviated red, black and yellow figurations clearly inspired by Miró. The traces left by a dry brush applied and lifted from the canvas are not so much expressive as consciously employed design elements that reflect precise planning. Like the somewhat later *Red and Blue*, c. 1943–1946 (p. 39), this picture shows a clear, cool will to achieve a certain compositional effect and keeping expressive excesses under control. *Blue (Moby Dick)* in particular strongly recalls compositions by Wassily Kandinsky from the 1940s, such as

The She-Wolf, 1943
Oil, gouache and plaster on canvas,
106.4 x 170.2 cm
New York, The Museum of Modern Art.
Purchase

The She-Wolf was the first work of Pollock's to have been acquired by an American museum, the Museum of Modern Art. This purchase was due in large part to the advocacy of Piet Mondrian, who also influenced Peggy Guggenheim to give Pollock his first one-man show, at her gallery Art of This Century.

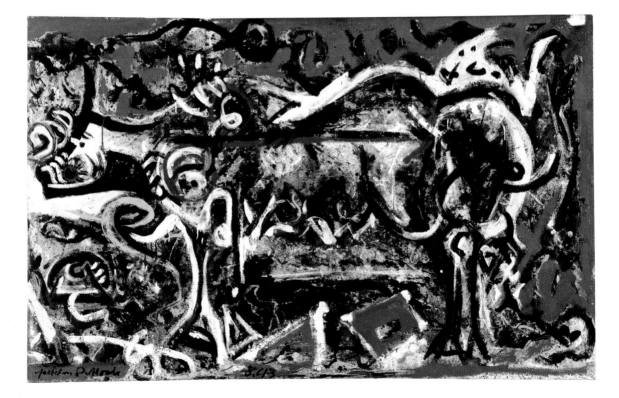

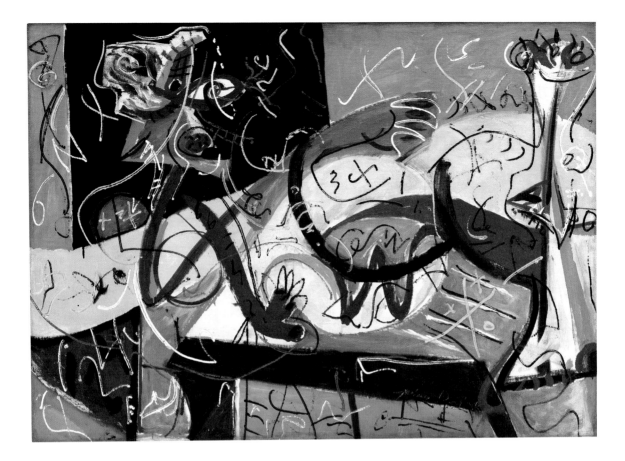

Stenographic Figure, 1942
Oil on canvas, 101.6 x 142.2 cm
New York, The Museum of Modern Art.
Mr. and Mrs. Walter Bareiss Fund

Especially in its early phase, Pollock's painting
was profoundly marked by an involvement with
Pablo Picasso. *Stenographic Figure* combines in-
fluences from Picasso's *Interior with Girl Draw-
ing* with the light, Mediterreanean palette of
Henri Matisse.

Bleu de Ciel, 1940, in which biomorphic, amoebic or crablike configurations are
distributed loosely across a dominant, cloudy blue picture plane. Here, too, we
find a controlled idiom and paint application, a clear distinction between figure
and ground, and a completely unpathetic, unexpressive evocation of a non-em-
pirical spiritual reality.

A similar dichotomy in Pollock's approach can be described by reference to
two significant paintings of this period. The first is *The She-Wolf*, 1943 (p. 42), al-
ready mentioned above. The title refers to the legend of the Capitoline mother-
wolf that suckled Romulus and Remus, founders of Rome. The animal's head,
turned to the left, and her strongly swollen teats are clearly recognizable. Not so
clear is the meaning of the bulging hindquarters. Citing prehistoric cave paint-
ings of which Pollock owned reproductions, the right-hand part of the animal's
body has been interpreted as the forequarters of a mastodon, a prehistoric ele-
phant. This would imply that the artist merged two different animals into a hy-
brid creature. In view of the synthesis of opposites, including opposite sexes,
seen in other paintings, this reading would appear plausible. Yet there is a lack of
visual evidence to prove it. How, for instance, can we explain the arrow that
points from the wolf's head to the mastodon's head? As a symbol of a wound in-
flicted by hunters, as seen in cave paintings, the arrow makes as little sense here
as it does as a symbol of fertility. Moreover, many of the interwoven biomorphic
or diamond-shaped linear configurations surrounding the animal resist any

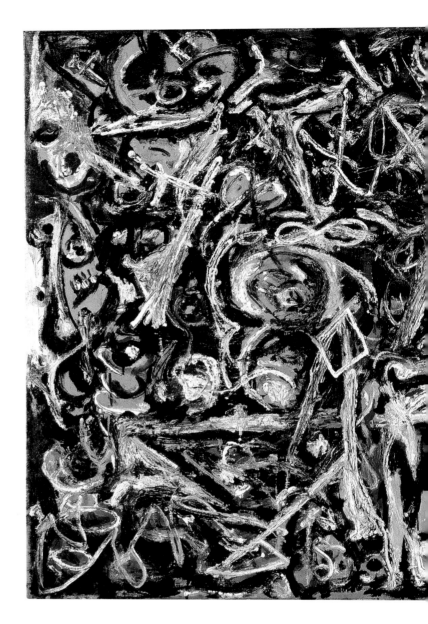

objective interpretation. This tendency of Pollock's to veil pictorial content rather than clarify it would grow even stronger in coming years, finally leading to the dripped and poured paintings, which, instead of being abstract in the sense of pure non-objectivity, used a dense all-over of lineatures to obscure figures or figurative forms which might emerge in the course of painting.

The body of *The She-Wolf* is defined by thick black and white contour lines. Beginning with a smooth, neutral gray ground, Pollock developed the figure with the aid of a mixture of gouache and oils with dry plaster added to the pigment to increase its tactile quality. Ultimately, it was only the final contour lines that caused the figure to appear out of the agglomeration of dripped, flung and poured interwoven masses of paint.

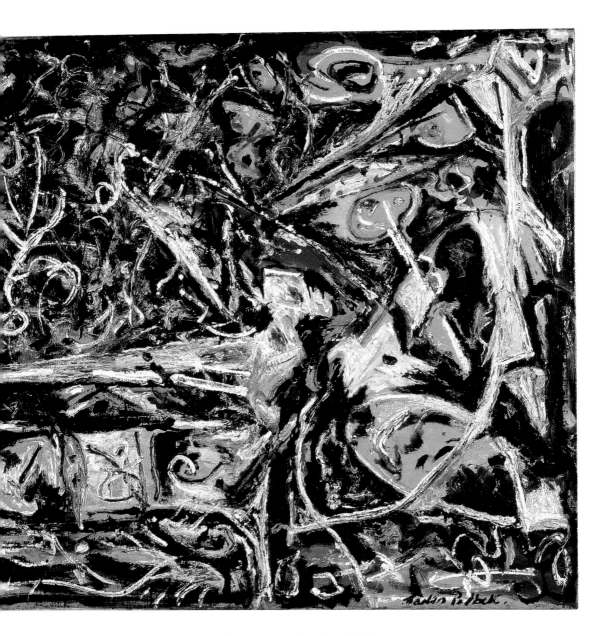

A different case altogether is *Stenographic Figure,* 1942 (p. 43). Its Mediterranean palette dominated by light blue, light red and a pastel yellow, as well as its free calligraphy of ornamental lines and scribbled numbers and letters, reflects the influence of Henri Matisse. While *The She-Wolf*, the first Pollock painting to be acquired by a major museum, marked a symbolic caesura in the artist's career, *Stenographic Figure* pointed the way to a greater popular recognition. Pollock had submitted the painting to the Spring Salon for young (exclusively American) artists at Peggy Guggenheim's gallery, whose jury included Marcel Duchamp, Guggenheim's assistant Howard Putzel, James Johnson Sweeney and Piet Mondrian. When Peggy Guggenheim made it clear to all that she was entirely unimpressed by Pollock's work, Mondrian, whose Constructivist art had

begun to grow rhythmically liberated in New York under the influence of jazz, expressed a surprising opinion: "I'm trying to understand what's happening here. I think this is the most interesting work I've seen so far in America. …You must watch this man."

This not only opened to the door for Pollock to Peggy Guggenheim's gallery but paved the way for his subsequent career. After Putzel, Sweeney, Matta and even Duchamp had spoken out for Pollock, Guggenheim began to plan his first one-man exhibition, to be held at Art of This Century from November 9 to 27, 1943. This would also be the first solo show of any American painter in her gallery. In the catalogue introduction, Sweeney celebrated Pollock's talent as "volcanic. It has fire. It is unpredictable. It is undisciplined. … It is lavish, explosive, untidy. … What we need is more young men who paint from inner impulsion without an ear to what the critic or spectator may feel – painters who will risk spoiling a canvas to say something in their own way. Pollock is one."

Most critics followed Sweeney's lead and devoted reserved but basically approving reviews to Pollock's show. Among them was Clement Greenberg (1909–1994), who would become probably the most influential art critic in the United States in the latter half of the twentieth century. Greenberg had been writing since the late 1930s for leftist journals such as *Partisan Review*, and would become famous through his books on Joan Miró and Hans Hofmann, as well as *Art and Culture*, published in 1961. His relationship with Pollock represented a unique symbiosis between artist and theoretician. At times it appeared that Greenberg developed the terminology and theories later recorded in *Art and Culture* on the basis of Pollock's work, and vice versa, that Pollock's success confirmed Greenberg's views on the purpose and destiny of modern art. A prime example was his opinion that the easel painting characterized a doomed bourgeois society and would inevitably be replaced by the mural. Greenberg accordingly encouraged Pollock to employ ever-larger formats, and perhaps even dictated the wording of Pollock's application for a Guggenheim Fellowship, mentioned above, in which he described the mural as the art form of the future. Greenberg was able to corroborate his strange if then widespread notion of the inevitable course of art history, derived from Hegel and Marx, by personally intervening in the development of painting to the point that it confirmed his prognoses. The fact that he favored Pollock's work over that of the French artist Jean Dubuffet (1901–1985), who in the U.S. was then considered the most important contemporary painter, contributed materially to the supplanting of Paris by New York as the major art center in the world, and the establishment of the New York School as the motor of the avant-garde.

Greenberg's rival was an art critic of about the same age, Harold Rosenberg (1906–1978). In his attempt to define a specifically American form of modern painting, Rosenberg coined the term "action painting," used in an article published in 1952, "The American Action Painters." In this essay, which became a sort of manifesto of American Abstract Expressionism, Rosenberg defined painting as an act, and declared the process of making to be considerably more significant than the finished picture itself. In the Abstract Expressionist movement, like Greenberg, he saw "the most vigorous and original movement in art in the history of this nation."

Yet in the end it was Greenberg who proved the shaping force in Pollock's career. The two men had been introduced to each other by Lee Krasner at a meeting with her teacher Hans Hofmann in early 1942. When Hofmann, whose influence on the development of Abstract Expressionism was considerable, criticized

Night Sounds, c. 1944
Oil on canvas, 109.2 x 116.8 cm
The Pollock-Krasner Foundation, Inc.,
New York

Pollock for working too little after nature, Pollock replied, "I am nature." This often-quoted statement would prove essential both to Pollock's self-understanding and the public understanding of his art. Although still echoing the pantheism of the theosophy which Pollock had imbibed through Krishnamurti's lectures, this notion was much more than an intellectual concept for him. Pollock's friends often spoke of the great empathy, sensibility and intensity with which he entered into the non-human world. The human-animal combinations in his early paintings, the concept of totemism, the merger of opposites, his recourse to precultural, prehistorical, or so-called primitive art, his rejection of a civilization that he held responsible for the hell of World War II, the transformation of the painter into a shaman who served as a medium from whose subconscious mind art flowed freely without conscious intervention – all of these aspects were concentrated in the three words of Pollock's statement, and were explained by it.

47

Totem Lesson 1, 1944
Oil on canvas, 177.8 x 111.7 cm
Collection of Mr. and Mrs. Harry W. Anderson

Totem Lesson 1 and *Totem Lesson 2* reflect the importance of American Indian art and rituals for the development of Pollock's painting. Stylistically, *Totem Lesson 2* anticipates the device of the cut-out, a form of collage with the aid of which he reintroduced the human figure into his work during the phase of linear abstraction.

The process of painting was not a production of art but an act in which the workings of the human unconscious were immediately reflected, and through which the artist was united with nature, the realm of animals and plants. Pollock's concern was not to work "after nature," but like nature, in parallel to it. Hence he could state, "My concern is with the rhythms of nature. … I work inside out, like nature."

Over the next three years, Pollock's work continued to be informed by two strategies which differed in terms of both form and substance. *Night Mist* (pp. 44–45), for instance, represents the tendency already described to suggest figures while preventing their precise identification by encouraging a variety of possible readings. The colors, squeezed straight from the tube, form an agitated, tangible surface. The deep black background, rather than being interwoven with this skein of lines, serves as a contrasting, heightening backdrop.

In contrast, a painting like *Night Sounds*, c. 1944 (p. 47), immediately recalls Miró. (Miró's influence, by the way, was also much evident in *Mural*, many of whose figurations recall the elongated personages in that artist's *Seated Personages*, which Pollock isolated and rhythmically repeated.) The expressive quality of the paint application has been reduced to a few summary arabesques; a few sparing lines are sufficient to define the guardian-like figure at the left, which stands out in sharp contrast to the black ground with the visual impact of a poster design.

In terms of subject matter, Pollock continued to invoke Indian cults in works such as *Totem Lesson 1* (p. 48), and *Totem Lesson 2* (p. 49). The former painting clearly recurs to the composition of *Birth*, although the vortex of individual forms seems less agitated here. The picture is dominated by a full-bodied individual figure standing on truncated legs. An orange triangle apparently symbolizes the female pubic area, into which an ejaculating, rodlike penis extends. The breast area is dissolved into a jumble of counteracting brushstrokes; eye and head are apparently indicated by a circular form encompassed by a semicircular line. The semicircular form is repeated not only in the upper right corner, but once again below this, next to a head which is clearly influenced by Picasso. This shape takes up once more a motif that was very important to Pollock, the half or crescent moon.

On the other hand, *Totem Lesson 2* seems in retrospect to anticipate paintings done after 1950. Although here the background remains calm, the isolation of figures and figure fragments points to the cut-out device by means of which Pollock would partially reintroduce the figure into his work during the phase of the drip paintings.

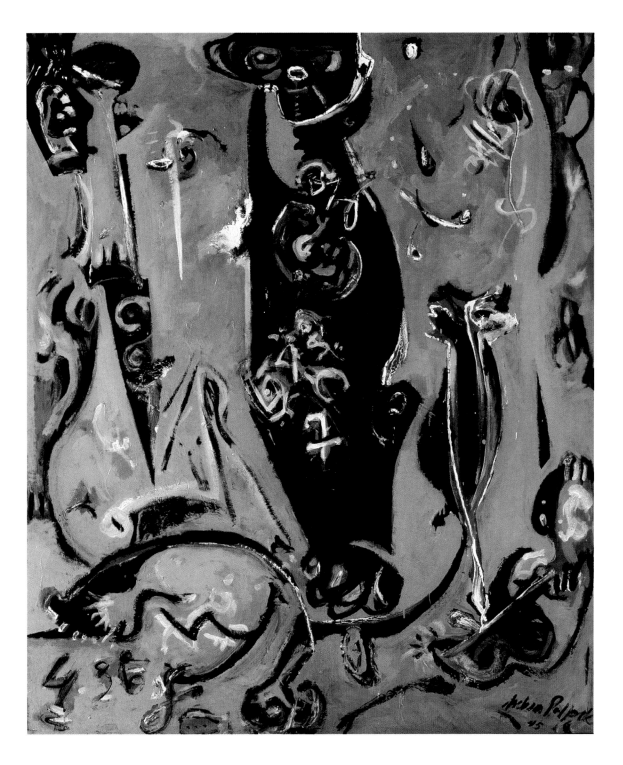

Totem Lesson 2, 1945
Oil on canvas, 182.9 x 152.4 cm
Canberra, National Gallery of Australia, 1986. 1046

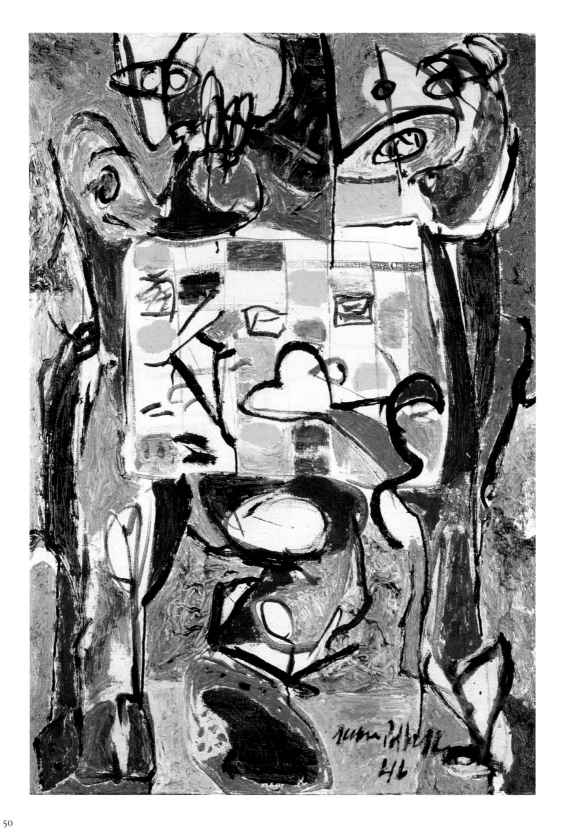

"Gothic, Morbid and Extreme"

The year 1945 brought a number of changes. The Arts Club of Chicago mounted Pollock's first one-man show outside New York, which traveled that autumn to the San Francisco Museum of Art. His second solo show was on view at Art of This Century from March 19 to April 14. It included *Totem Lesson 1* and *Totem Lesson 2, Night Mist, Two* (p. 51), and *There Were Seven in Eight* (pp. 52–53). *Two*, 1943–1945, clearly took up the theme of *Male and Female* (p. 34), with an apparently even stronger emphasis on sexual content. *There Were Seven in Eight*, about half the size of *Mural*, was begun before that work but not finished until spring 1945. As Lee Krasner reported, figures, heads and parts of bodies were clearly visible at the beginning. When asked why he later covered them with paint squeezed directly from the tube or dripped on the canvas, Pollock explained, "I choose to veil the imagery." Robert Motherwell, who could be described as an intellectual leader among the Abstract Expressionists, criticized Pollock's early paintings, saying he apparently had difficulty in finding the right subject matter. In a sense Motherwell was right, in view of the diverse and basically unrelated motifs of these paintings and the obfuscating veil of color Pollock spread over them. It was only logical to begin dispensing with subject matter altogether, or, as in *There Were Seven in Eight*, taking it as a point of departure and finally rendering it entirely unrecognizable.

The reviewers of Pollock's second show with Peggy Guggenheim were of two minds. Some scoffed that his pictures looked like "baked macaroni" or an "explosion in a shingle mill." Greenberg, however, turned his supportive rhetoric up a notch and declared Pollock to be "the strongest painter of his generation and perhaps the greatest one to appear since Miró." True, his art may be ugly, but "all profoundly original art looks ugly at first."

It was also Greenberg, like Sweeney before him, who found a title for a Pollock painting: *Gothic* (p. 55). The artist himself had proceeded from the motif of a dancer, saying that a memory of Picasso's *Three Dancers*, 1925, was continually in his mind during the process of painting. *Gothic* confronts us with a dense mass of shapes and lines. The black that works like a background at the upper edges functions in the remainder of the picture as a rhythmically curving contour line encompassing fields of cool blue and green, often accompanied by a dry, blurred red. Associations with feet and hands seem plausible at one moment, only to appear entirely arbitrary and unimportant at the next. Only an

Two, 1943–1945
Oil on canvas, 193 x 110 cm
Venice, Peggy Guggenheim Collection

The Tea Cup (Accabonac Creek series), 1946
Oil on canvas, 101.6 x 71.1 cm
Baden-Baden, Frieder Burda Collection

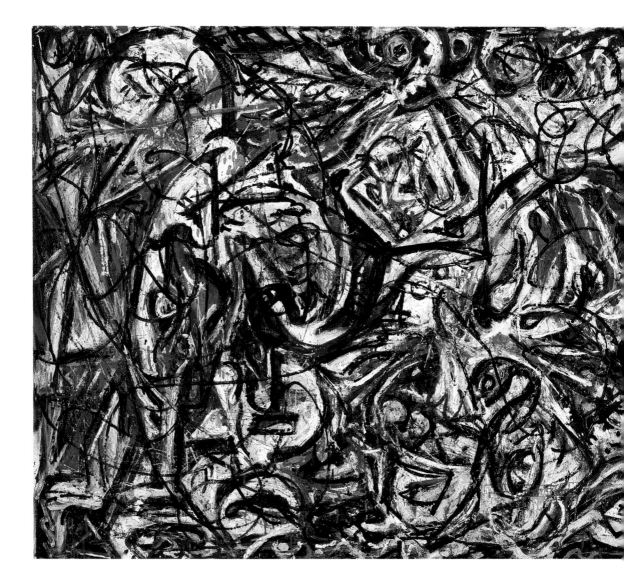

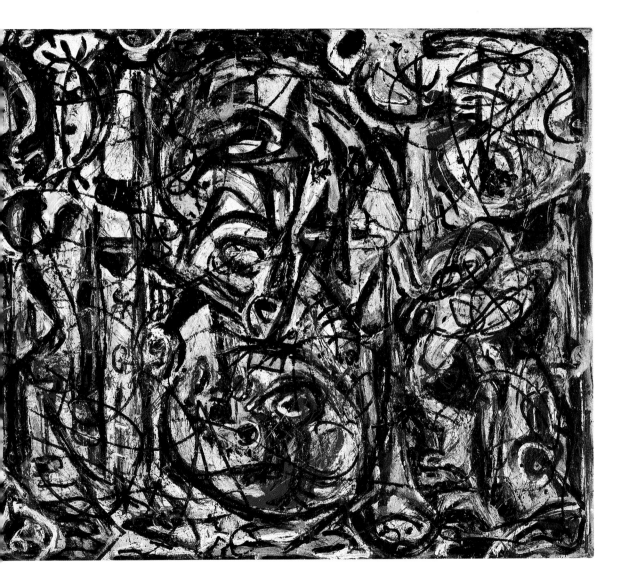

There Were Seven in Eight, c. 1945
Oil on canvas, 109.2 x 259.1 cm
New York, The Museum of Modern Art.
Mr. and Mrs. Walter Bareiss Fund

evocation of a dancing figure in rhythmical motion constantly asserts itself, but in the form of a simultaneous vibration of the entire picture plane rather than a sequence of movements, as in *Mural*. There, the horizontality of the composition permits not only a step-by-step reading of the motion sequence, but, concomitantly, a reconstruction of its process of making.

As we may infer from Greenberg's characterization of Pollock as "gothic, morbid and extreme," he did not mean the term "gothic" in reference to historical late medieval architecture and art, which would in fact be difficult to associate with the sumptuous swing of the contours here. "Gothic" was intended metaphorically, to describe what Greenberg saw as the raw, harsh nature of Pollock's art.

In August 1945, Lee Krasner began trying to persuade Pollock to leave New York, probably in the hope that a move to the country would help him tame his excessive drinking. With $5000 borrowed in part from a bank and in part from Peggy Guggenheim, the pair bought The Springs, a house in East Hampton, Long Island, a town where many artists spent their summers and where Motherwell owned a house. On October 25, 1945, Lee Krasner and Jackson Pollock were married in New York, in a church on Fifth Avenue. Their witnesses were to be May Tabak, Harold Rosenberg's wife, and Peggy Guggenheim. Yet as Peggy declined at the last moment, the church's custodian stood in for her alongside May Tabak.

In early November the newlyweds moved into their new house on Long Island. In addition to the two-story main house, there were various smaller buildings on the property, including the barn that Pollock would use as a studio from summer 1946 onwards. It was here that he would execute most of the large-format drip paintings that would make him world famous.

The house had neither hot water nor heating, and despite a renewed contract with Peggy Guggenheim that brought the Pollocks a monthly stipend of $300, they were extremely poor. Throughout the winter of 1945/46 Pollock was involved in fixing up the house and painted very little. It was not until he had the barn moved to the edge of the lot in summer 1946 that he found time and space to work. From the barn he had a view over Accabonac Creek, after which the group of paintings of that title were named. A short time later, the *Sounds in the Grass* series emerged.

The feeling of euphoria induced by long walks along the seashore, experiences of nature and the expansive countryside precipitated in a lighter and richer palette. Although paintings such as *The Key*, 1946 and *The Water Bull*, c. 1946 (pp. 56–57) evince a highly condensed surface, their coloristic orchestration mitigates the sense of closeness, while interspersed planes of opaque, unmodulated color lend the image a certain tranquillity. Primary contrasts of yellow and red give these paintings a brilliance and intensity that apparently derived in part from Pollock's knowledge of the Fauvism of Matisse. While one cannot speak of carefree joie de vivre in connection with the *Accabonac Creek* series, a painting like *The Tea Cup*, 1946 (p. 50), does possess a balance and serenity that are rarely found in Pollock's work. But the *Accabonac Creek* series was to prove no more than a brief intermezzo.

When he launched into the series called *Sounds in the Grass* in 1946, Pollock set off on a road which he had previously tentatively explored and now began to follow uncompromisingly: the road to linear abstraction. *Croaking Movement* (p. 58) is divided by straight, angling white lines overlying a web of red and green, yellow and orange applied in short brushstrokes that congeal into rest-

Gothic, 1944
Oil and enamel on canvas, 215.5 x 142.1 cm
New York, The Museum of Modern Art.
Lee Krasner bequest

The art critic Clement Greenberg, one of Pollock's most important advocates, once referred to the present painting as "gothic, morbid and extreme." The term "gothic" was not meant in reference to the eponymous historical period in art, but as a synonym for harsh and ugly, which to Greenberg's mind were positive traits.

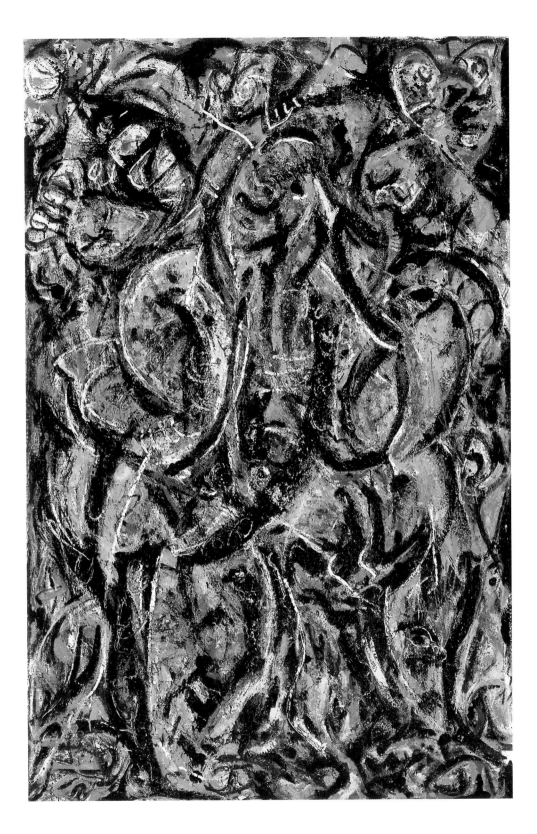

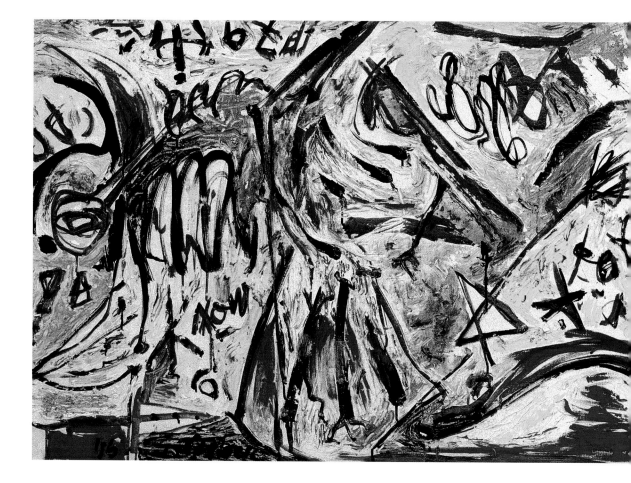

The Water Bull, c. 1946
Oil on canvas, 76.5 x 213 cm
Amsterdam, Stedelijk Museum

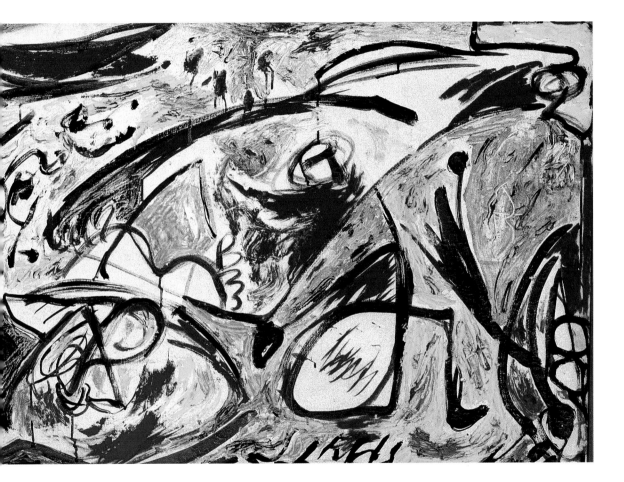

PAGE 58:
Croaking Movement (Sounds in the Grass series), c. 1946
Oil on canvas, 137 x 112.1 cm
Venice, Peggy Guggenheim Collection. The Solomon R. Guggenheim Foundation, New York

PAGE 59:
Shimmering Substance (Sounds in the Grass series), 1946
Oil on canvas, 76.3 x 61.6 cm
New York, The Museum of Modern Art. Mr. and Mrs. Albert Lewin and Mrs. Sam A. Lewisohn Funds

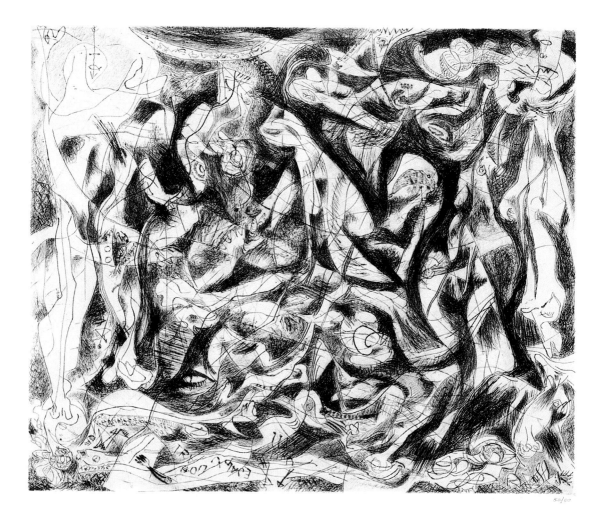

Untitled, 1944/45
Engraving and drypoint, printed in brown-
black (printed 1967), 37.3 x 45.8 cm
New York, The Museum of Modern Art.
Gift of Lee Krasner Pollock

lessly vibrating nodes of color. This retroactive structuring of the surface, recal-
ling the sharp-angled faceting of earlier works, was waived in succeeding paint-
ings, such as *Eyes in the Heat* and *Shimmering Substance* (p. 59). The latter paint-
ing in particular conveys the impression that the color literally vibrates. The eye
finds no grip or point of rest, wandering from one slashing brushstroke to the
next, and only gradually discovers beneath the network of strokes a circular yel-
low shape that seems to hover in the pictorial space. The beholder has the sense
of an hallucination.

Pollock had first tested this method of building up an image from inter-
locking brushstrokes in the medium of etching. That autumn he had begun to
work in a shop headed by Stanley William Hayter (1901–1988), an English print-
maker who had emigrated to New York from Paris. His Atelier 17 was located
opposite Pollock's apartment, and was also frequented by William Baziotes and
Robert Motherwell. Hayter instructed Pollock in the technique of drypoint and
etching. Pollock reworked most of his etchings with ink and gouache; in many
cases, pure impressions were not taken from the plates until after his death (pp.
60 and 61).

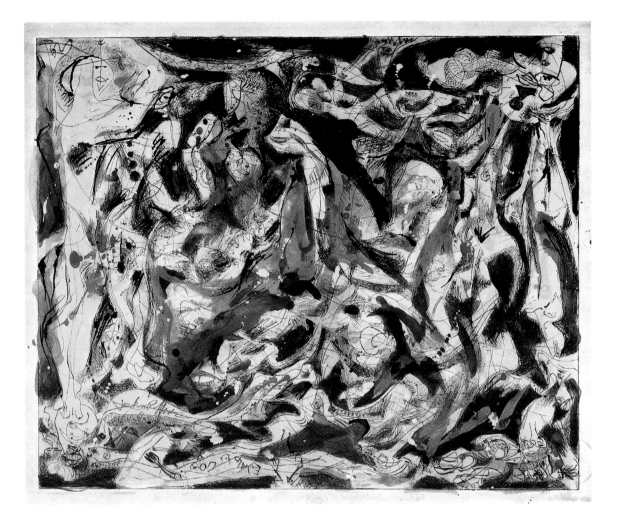

Untitled, c. 1945
Ink and gouache on engraving and drypoint,
44.9 x 54.3 cm
Collection The Guerrero Family

PAGE 60 BELOW:
Stanley William Hayter
Combat, 1936
Engraving, 39 x 49 cm
New York, Brooklyn Museum of Art Collection,
by exchange

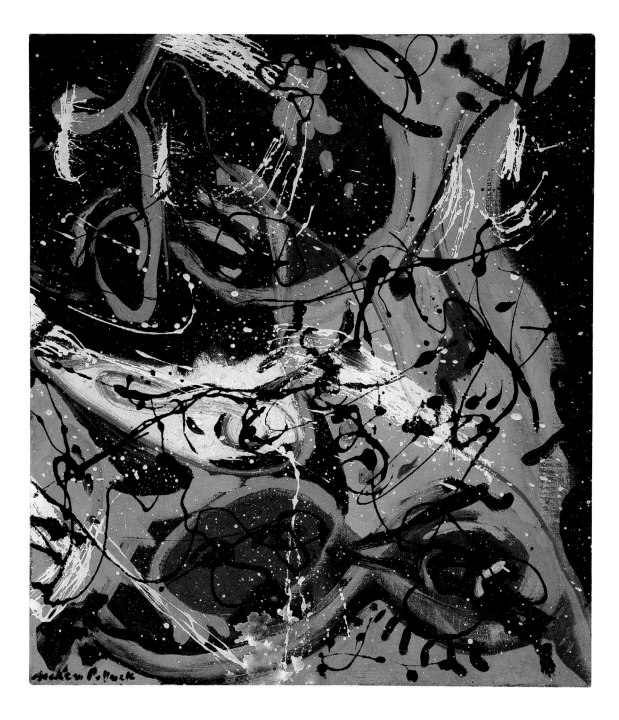

Composition with Pouring II, 1943
Oil on canvas, 64.7 x 56.2 cm
Washington, DC, Hirshhorn Museum and
Sculpture Garden, Smithsonian Institution.
Gift of Joseph H. Hirshhorn, 1966

Pollock's technique was influenced not only by Hayter's practice of engraving a plate in rapid sweeps (p. 60 below), but also by his method of continually turning the plate while working in order to avoid any fixation on top and bottom, right and left. This procedure would have its effect on Pollock's later drip paintings, in which he spread the canvas on the floor and applied the paint from all sides.

More important for Pollock's development of linear abstraction than Kandinsky, with whom he was often associated in reviews in the late 1940s, was André Masson, the French Surrealist mentioned above. Masson's influence is immediately apparent in an etching like *Rape*, 1941, printed in 1958. The technique of dripping and pouring, which Pollock now began to use exclusively and to ever greater effect, had been previously used both by him and other artists. Apart from Siqueiros, as mentioned, these included Francis Picabia (1879–1953), who sprayed ink on paper in *La Sainte Vierge*, 1917, and Max Ernst, who employed dripped paint in *Young Man Disturbed by the Flight of a Non-Euclidean Fly*, 1942/47. Hans Hofmann, too, had experimented with dripping and pouring paint from 1940 onwards. Hofmann's *Spring*, 1940 (p. 63), bears such a close resemblance to Pollock's 1943 *Composition with Pouring II*, 1943 (p. 62), that despite Lee Krasner's statement to the contrary, it is hardly conceivable that Pollock did not know the picture. A further important precursor was Arshile Gorky (1904–1948), a Surrealist artist of Armenian origin of whose work Pollock was aware.

If we extend this list of well-known artists to include lesser-known painters who likewise experimented with dripping, such as Janet Sobel (1894–1968) and Knud Merrild (1894–1954), it becomes clear how little significance attaches to the technique as such. Jackson Pollock's achievement did not inhere in the employment of a certain procedure but in the radicality of the works he produced with its aid.

Hans Hofmann
Spring, 1940 (?)
Oil on wood, 30.5 x 36.7 cm
New York, The Museum of Modern Art.
Gift of Mr. and Mrs. Peter A. Rübel

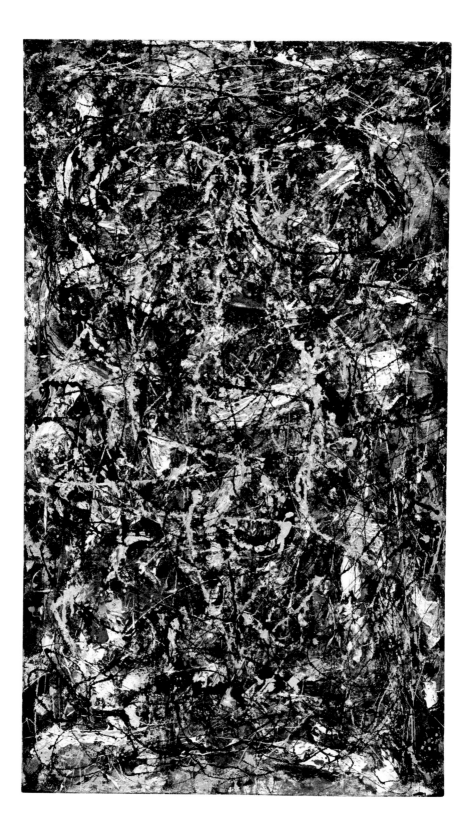

"An Easy Give and Take"

After the barn was converted into a studio, Pollock finally had enough space to work on large formats. By spreading the canvas on the floor, he could approach it from all four sides. Pollock seldom applied paint with a brush; he used a stick or palette knife to drip it from the air without touching the canvas. Holding a paint can in his left hand, he stepped toward or onto the canvas again and again, slinging or dripping the paint over the horizontal surface. This was done with great rapidity, if with intervals to permit the paint to dry or consider how to proceed, as can be seen from Hans Namuth's photographs and films of Pollock at work (p. 65).

At Motherwell's request, Pollock described his method in the winter of 1947/ 48, in the first (and last) issue of the journal *Possibilities*, co-edited by Motherwell and Rosenberg: "I prefer to tack the unstretched canvas to the hard wall or floor. I need the resistance of a hard surface. On the floor I am more at ease. I feel nearer, more a part of the painting, since this way I can walk around it, work from the four sides and literally be in the painting. This is akin to the method of the Indian sand painters of the West. … When I am in my painting, I'm not aware of what I'm doing. It is only after a sort of 'get acquainted' period that I see what I have been about. I have no fears about making changes, destroying the image, etc., because the painting has a life of its own. I try to let it come through. It is only when I lose contact with the painting that the result is a mess. Otherwise there is pure harmony, an easy give and take, and the painting comes out well."

Becoming one with the painting, in other words, was not only a matter of motif or iconography but the artist's express intention at the moment of creating the image and the condition of its being successful. The painting, rather than representing a passive surface waiting to be filled, became the artist's active counterpart.

The dancelike movements Pollock made during the painting process have frequently been described as encouraging a free flow of unconscious imagery and its immediate communication to the canvas. Accordingly, one of his first pure drip paintings, *Full Fathom Five*, 1947 (p. 64), has been interpreted as a representation of the unconscious. The title – from Ariel's song in Shakespeare's *The Tempest* – was suggested by Ralph Manheim, a neighbor of Pollock's on Long Island and translator of the works of Jung. (Manheim was also responsible for the

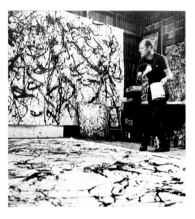

Jackson Pollock works on *Autumn Rhythm: Number 30*, 1950
Photograph by Hans Namuth
© Hans Namuth Ltd.

Full Fathom Five, 1947
Oil on canvas with nails, tacks, buttons, key, coins, cigarettes, matches, etc. 129.2 x 76.5 cm
New York, The Museum of Modern Art.
Gift of Peggy Guggenheim

Cathedral, 1947
Enamel and aluminum paint on canvas,
181.6 x 89 cm
Dallas, TX, Dallas Museum of Art. Gift of
Mr. and Mrs. Bernard J. Reis

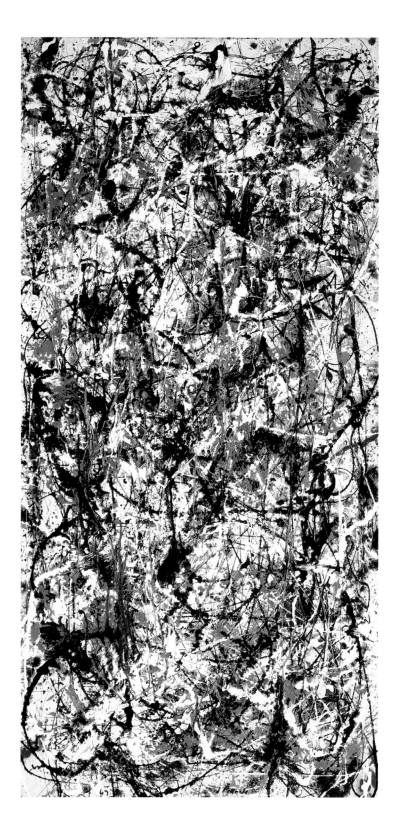

Comet, 1947
Oil on canvas, 94.3 x 45.5 cm
Ludwigshafen, Wilhelm-Hack-Museum

Comet is one of those wonderful works of medium-sized format whose encrusted surface lends them not only a tangible quality but a seemingly infinite visual depth. Here, we have the impression of a night sky through which shoots a line like a meteor trail.

Summertime: Number 9A, 1948, 1948
Oil and enamel on canvas, 84.5 x 549.5 cm
London, Tate Gallery. Purchased 1988

For *Summertime* Pollock chose an unusual
format – extremely wide at five-and-one-half
meters, but only 84 centimeters high. In terms
of its lyrical, dancing movement, the composi-
tion recurs to the initial work of the phase of
linear abstraction, *Mural*.

title of *Alchemy*, 1947.) In the present case, his suggestion may have been inspired
by the bluish-greens that recall the colors of the ocean, the sea-swell motion of
the multiple paint layers and veils, and the white shimmering through from the
underpainting like light reflections under water. True, Manheim may have been
thinking of Jung's interpretation of the sea as a symbol of the collective uncon-
scious, and Pollock may have accepted his title and the resulting trains of
thought and association. Yet this does not necessarily imply that Pollock inten-
ded the image as a representation of the unconscious.

Now, the dripping technique involves the risk of being seen as leading to un-
controlled results or as more or less random action. Pollock had continually to
defend himself against the accusation that his pictures were meaningless explo-
sions of unchanneled energy. His fifth one-man show, now that Peggy Guggen-
heim had left for Venice, was held with Betty Parsons, from January 5 to 23, 1948.
It was the first show to include Pollock's drip paintings, and the press reaction
was for the most part indignant. In *The New York Times*, the critic Robert Coates
declared, "I can say of such pieces … only that they seem mere unorganized ex-
plosions of random energy, and therefore meaningless." At a podium discussion
sponsored by *Time* magazine on October 11, 1948, on the subject "Is modern art,
considered as a whole, a good or a bad development …?" Pollock's *Cathedral*
played a central role. The opinions expressed there included that of the curator
of graphic art at the Metropolitan Museum, who stated, "I suspect any picture I
think I could have made myself." Aldous Huxley, author of *Brave New World*, be-
lieved such art "raises a question of why it stops when it does. The artist could
go on forever (laughter in the auditorium)." And Theodore Greene, professor at
Yale University, opined that *Cathedral* would make an excellent design for a
necktie.

Pollock rejected such criticisms, which came in a variety of forms and from
many quarters. In a 1951 interview he maintained that, based on his experience,
he certainly was capable of controlling the flux of paint. Huxley's critique that
the painting might just as well have limits different from those it actually had,
which could be understood as a critique of the all-over principle itself, was
something Pollock had long turned to his own advantage and accepted as a
characteristic trait of his work. And in 1950, when an anonymous critic in *Time*
repeated the Italian art critic Bruno Alfieri's opinion that his paintings were
primarily characterized by chaos, Pollock sent an angry telegram to the editors:
"SIR: NO CHAOS DAMN IT. DAMNED BUSY PAINTING AS YOU CAN

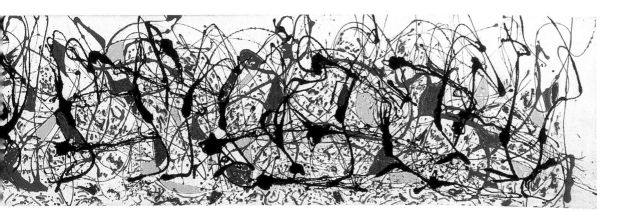

SEE…" The importance Pollock attached to clearing up these issues is indicated by handwritten notes which were published posthumously:

"… total control --------- denial of
the accident --------------
States of order ----------
organic intensity --------------
energy and motion
made visible
memories arrested in space…"

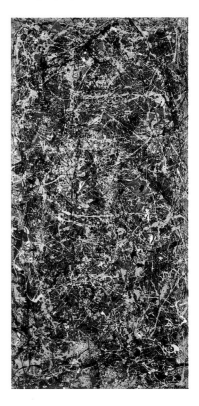

Number 5, 1948, 1948
Oil, enamel and aluminum on hardboard,
243.8 x 121.9 cm
Los Angeles, CA, Collection David Geffen

So there are indications that Pollock was very much aware of the dangers involved in his painting technique. He denied that chance played a role by referring to his experience in applying paint, and even went so far as to deny the existence of chance in general. This is certainly logical when we view Pollock's paintings in light of the notes just cited, as manifestations of energy and motion, and as an "arresting" of physical memories stored in his arms, hands and mind. Once we accept this premise, none of the movements that lead to a painted image can be random, a result of mere chance. At this point we should re-emphasize that the exclusive use of dripping and pouring as a picturemaking method is important only with respect to the aesthetic qualities of the paintings Pollock produced in his most fruitful years, 1947 to 1950. If these had merely been monotonous variations on a certain theme, repetitive developments of an unchanging method, and not of such outstanding quality, variety and tension, the specific technique employed would hardly be worth a marginal note. Pollock himself knew this very well: "Naturally, the result is the thing – and – it doesn't make much difference how the paint is put on as long as something has been said. Technique is just a means of arriving at a statement."

The large formats considered typical of Pollock were by no means the rule. Normal formats like that of *Comet*, 1947 (p. 67), are more commonly found than extremely large ones like that of *Summertime: Number 9A* (pp. 68–69), which, at five-and-a-half meters in length and 84 centimeters in height (218 x 33 1/4 feet) is probably unique in the œuvre. In addition, the two works provide evidence of the stylistic range of which Pollock was capable. The multiple paint layers in *Comet*, for instance, lend the surface an opaque density through which a final white paint trace runs like the trail of a meteor in the night sky. Loosely swing-

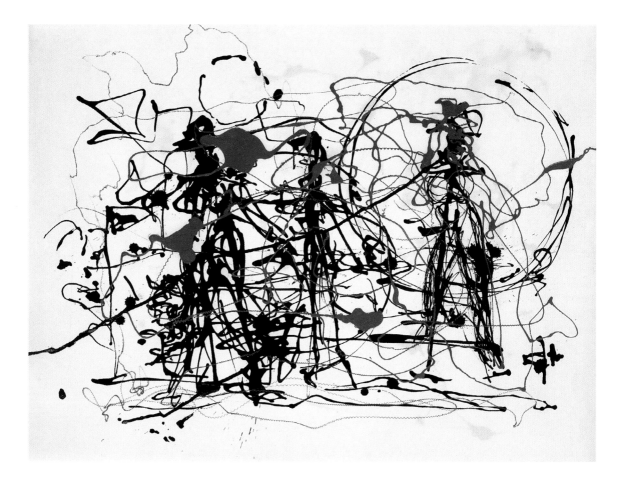

Untitled, c. 1948/49
Ink and enamel on paper, 56.8 x 76.2 cm
New York, The Metropolitan Museum of Art.
Gift of Lee Krasner Pollock, 1982 (1982.147.27)

ing lines congeal into black nodes; traces of the palette knife encrust the surface; the picture possesses both a tangible solidity of surface and an infinite visual depth.

Summertime is composed in an entirely different way. The canvas is not completely covered with paint. As in *Mural* (pp. 8–9), the basic theme appears to be a dancing configuration of lines which in later steps were filled in with fields of blue and yellow and accompanied by shorter lines and dots of color. The flux of dancing movement encounters its response in a staccato of secondary paint applications.

Summertime also provides evidence that Pollock's compositions were by no means always determined by the all-over principle. Here both left and right margins have been respected, and the canvas is not homogeneously covered with paint. It would seem more appropriate to speak of numbers of condensations, energy foci and points of concentration that set the surface in a state of tension. Pollock trimmed this canvas after finishing it, as indicated by the interrupted linear sweeps seen especially at the upper edge. This common practice of determining the final format and thus the finished image by trimming portions off an originally larger surface is itself enough to counter the supposition of arbitrariness. The pictorial field is not a random section of some larger whole, but a field suffused with the utmost of concentration and tension. Since the same method

was used for formats ranging from small to enormous, the application of the paint had to be well considered, and a precise knowledge of its degree of viscosity and great practice in controlling the motions used to apply it were required.

That a general categorization as drip paintings can blind us to the true diversity of these works becomes clear when we compare a few of them. While *Untitled*, c. 1948/49 (p. 70) gives the impression of a hallucination of an expanse populated by figures, *Number 4, 1948: Gray and Red* (p. 71) calls to mind a view through a microscope. Spermatozoan pourings rush like vectors in various directions, while knots of lines establish emphases and centers of tension. Pollock's tendency to blur the conventional distinction between graphic and painterly means becomes eminently clear in view of such stark, strongly linear compositions.

Heavy, massive accents (*Number 12A, 1948: Yellow, Gray, Black;* p. 72) that nonetheless suggest a hovering state, stand opposed to weblike, vibrating works full of nuances of palette from ocher through dark red to yellow and gray (*Number 5, 1948;* p. 69). Violent color contrasts and a dazzling range of hues (*Number 15, 1948: Red, Gray, White, Yellow;* p. 73 above) are found just as much as concentrations on a single contrast, as that between white and black or light and dark in *Untitled (White on Black I)*. The lineatures that in this case appear unfocused, broad and frequently interrupted, in other works stand out razor-sharp, aggressive and decisive against the ground, as in *Phosphorescence,* 1947.

Number 4, 1948: Gray and Red, 1948
Oil and plaster on paper, 57.4 x 78.4 cm
Los Angeles, CA, Frederick R. Weisman
Art Foundation

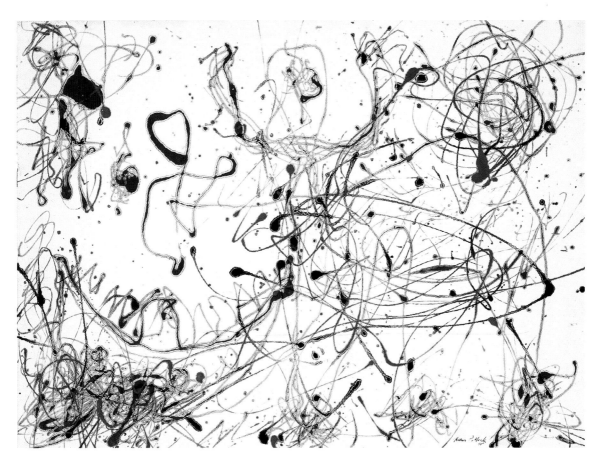

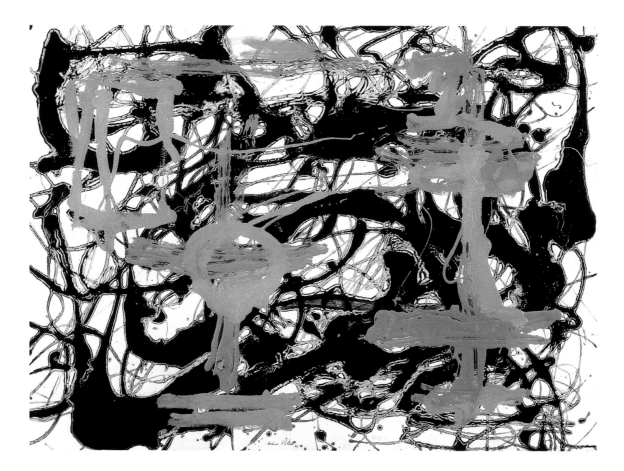

Number 12A, 1948: Yellow, Gray, Black, 1948
Enamel and plaster on paper, 57.2 x 77.8 cm
Pittsburgh, PA, Collection Mr. and Mrs. Stanley
R. Gumberg

PAGE 73 ABOVE:
Number 15, 1948: Red, Gray, White, Yellow,
1948
Enamel on paper, 56.5 x 77.5 cm
Richmond, VA, Virginia Museum of Fine Arts.
Gift of Arthur S. Brinkley, Jr.

PAGE 73 BELOW:
Untitled (Cut-Out Figure), 1948
Oil, enamel, aluminum, glass and nails on card-
board and paper, mounted on hardboard,
78.8 x 57.5 cm
Private collection

Pollock never entirely gave up the figure, as evidenced by works character-
ized by the cut-out technique, which basically could be described as collages,
such as *Untitled (Cut-Out)*, c. 1948–1950 and *Untitled (Cut-Out Figure)*, 1948
(p. 73 below). The short-armed human figure here represents another recourse
to the work of Matisse. It may have been patterned on a mirror image of Ma-
tisse's gouache cut-out *The Clown*, from the series *Jazz*, 1947. In the case of the
largest Pollock painting employing cut-outs, *Out of the Web: Number 7, 1949*,
the source of inspiration might once again have been Miró.

A group of three large-format works mark both the zenith and the termina-
tion of Pollock's most fruitful creative period, from 1947 to 1951. In *Number 32,
1950* (p. 76), we find a number of nodes, apparently established in ever-fresh
attacks. What dominates here is not the sweep of one extensive, unifying line, as
in *Mural* or *Summertime*, but the relationship of separately established, various-
ly interlinked centers of energy. The surface is articulated neither in terms of a
uniform rhythm nor a superimposition and condensation of paint layers; rath-
er, autonomous foci of color appear to explode independently of one another at
various points on the canvas. The brownish color of the canvas has the effect of
a first paint layer or background color, not only in reproduction but in the origi-
nal as well.

Now, the conventional wisdom among writers on Pollock's drip paintings is
that they generally neutralize the distinction between figure and ground, a fac-

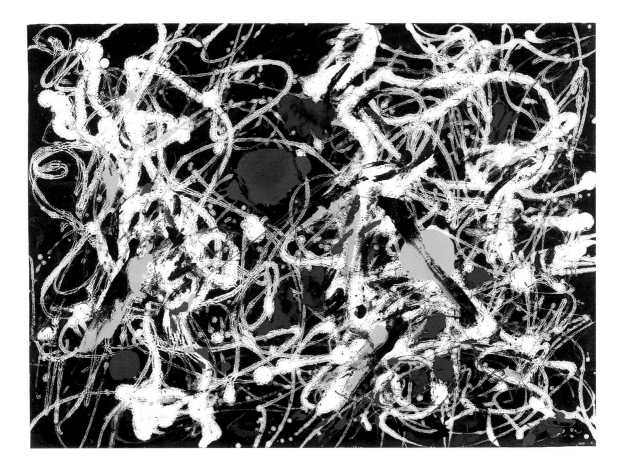

tor closely allied with the theory of the all-over. As the above comparison indicates, this view is in need of revision. Not only in the relatively stark *Number 32, 1950*, but also in works like *One: Number 31, 1950* and *Autumn Rhythm: Number 30, 1950* (pp. 78–79), the artist clearly took account of the picture edges and therefore distinguished between the format of the paint support and the composition of the applied image. Paint support (canvas) and painting are by no means identical, as is the case with the non-relational paintings of Frank Stella or the non-objective paintings of Barnett Newman. To argue that figure and ground are neutralized in *One: Number 31, 1950*, for instance, because the image evinces no definite form but only a compact, restless texture that appears to continually advance and recede and allows the eye no point of rest, is banal.

More to the point than a discussion of such conventional criteria is the fact that, like all good painting, Pollock's drip paintings evince different degrees of tension, in which a key role is played by image/edge relations and empty passages or negative shapes within the image. In *One: Number 31, 1950* (p. 77) the handling of these coordinates is quite different from that in *Autumn Rhythm: Number 30, 1950*. The palette in the two works is quite similar, being dominated by a modulation of brown through gray and black and white values. Yet the degree of condensation is different – the degree to which lines of a certain thickness form centers, the degree to which they permit or obscure negative spaces. In both, however, we immediately recognize that the borders of the image were

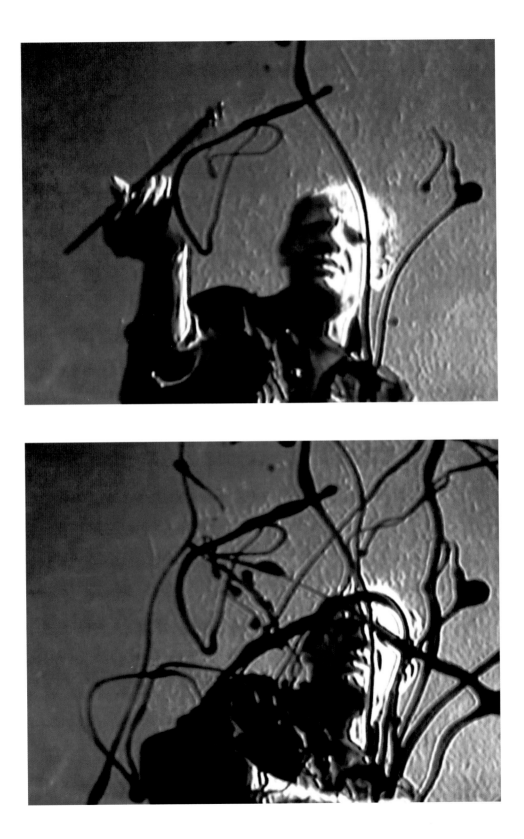

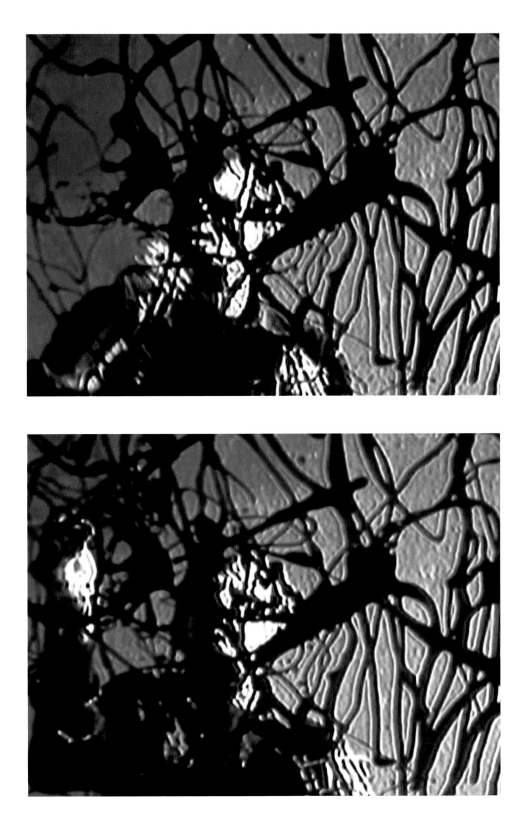

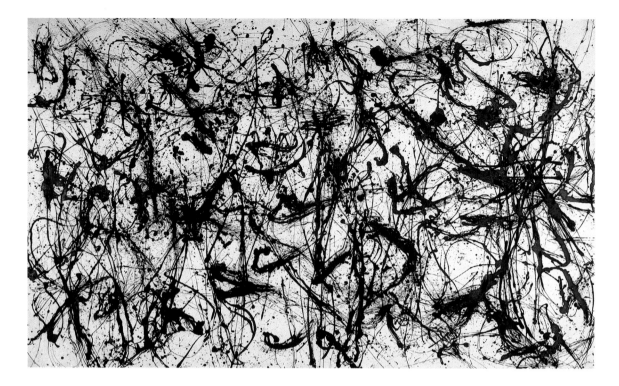

Number 32, 1950, 1950
Enamel on canvas, 269 x 457.5 cm
Düsseldorf, Kunstsammlung Nordrhein-
Westfalen, K20

In *Number 32, 1950*, Pollock varies the all-over
principle by establishing a number of different
focuses of energy which lend tension to the
composition, rather than enliven it by means of
modulations in a homogeneous, dancing linear
pattern.

PAGES 74–75:
Hans Namuth and Paul Falkenberg
Stills from the film *Jackson Pollock*, 1951
16mm film
©Hans Namuth Ltd.

taken into account in the process of painting and that they affect the appearance
of the final composition.

During this phase, when he produced probably the most significant paint-
ings of his career, Pollock was entirely abstinent, likely aided by tranquillizers
prescribed by Dr. Edwin Heller of East Hampton. Contrary to the much too
glibly quoted opinion, these works and their radical questioning of the tradi-
tional definition of painting were definitely not the products of a drinker in
delirium.

In the late summer and autumn of 1950, the photographer Hans Namuth
began to take pictures of Pollock at work. Eventually Namuth approached him
with the idea of making a documentary film. Pollock agreed, but as filming out-
doors involved unforeseen problems, the sessions went on through the week-
ends of October and November. Finally Namuth suggested that Pollock work on
a pane of glass under which the camera was positioned (pp. 74–75). The final
sequences were filmed only three days before the opening of Pollock's fourth
one-man show, at the Betty Parsons Gallery, on November 28, 1950. That eve-
ning a little party was planned to celebrate the completion of work. It ended in
disaster. After Pollock returned to the house from the icy cold November after-
noon he began drinking uncontrollably. Again and again he whispered to
Namuth, "I'm not a phony," and finally, to the guests' horror, he upended the
table and all it contained onto the floor.

This event marked the final turning point in Pollock's life. The following
years, until his death, saw his alcohol consumption steadily rise and his creative
powers steadily decline. Why the film work with Namuth triggered such a pro-
found crisis has never been adequately explained. In a sense, Pollock apparently
felt that his acting in front of a camera (something that would later be seminal

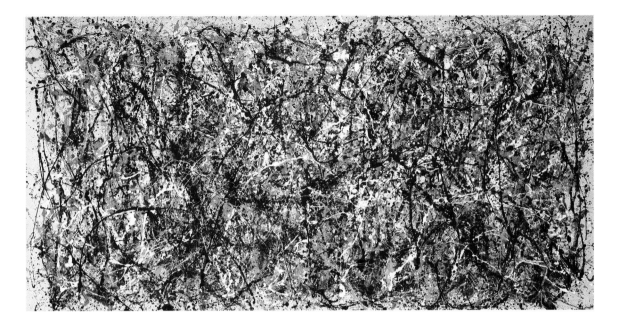

to the development of performance art) was a sham, as if he were only pretend-
ing to paint for the sake of the film's audience. What in the loneliness of the
studio had been a profound and intimate interplay between him and the canvas
became play-acting in front of an imaginary public, and thus a betrayal of him-
self and his art. In fact at a previous date, for the photographer Rudolph Burck-
hardt, Pollock had only pretended to paint.

That the crisis did not pass but worsened over the following weeks had to do
with the financial failure of the Betty Parsons show, which dashed Pollock's
hopes of being able to improve his dire situation by selling pictures. This show,
declared one of the best of the year 1950 by *Artnews*, was also the first on which
Greenberg wrote no positive review. As a result, Pollock began to suspect Green-
berg of favoring his arch rival, Willem de Kooning (1904–1997), and their long
friendship seemed to be going on the rocks.

One: Number 31, 1950, 1950
Oil and enamel on unprimed canvas,
269.5 x 530.8 cm
New York, The Museum of Modern Art.
Sidney and Harriet Janis Collection Fund (by
exchange)

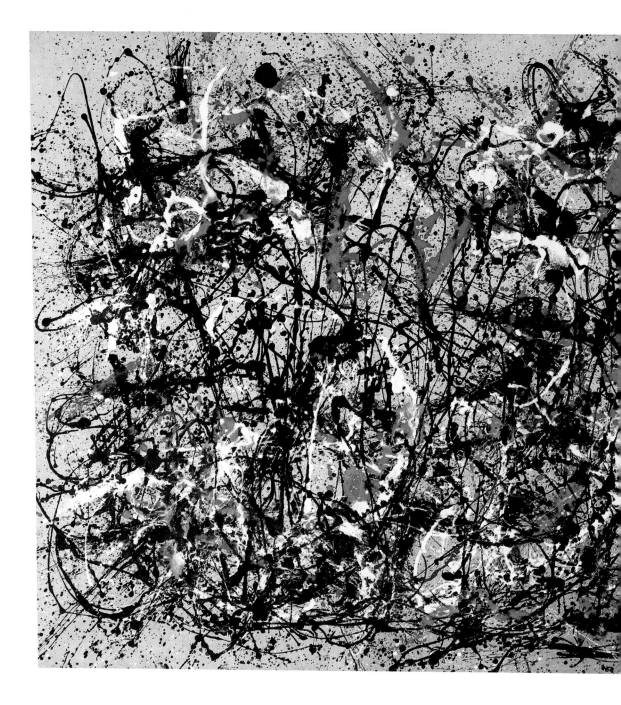

Autumn Rhythm: Number 30, 1950, 1950
Oil on canvas, 266.7 x 525.8 cm
New York, The Metropolitan Museum of Art,
George A. Hearn Fund, 1957 (57.92)

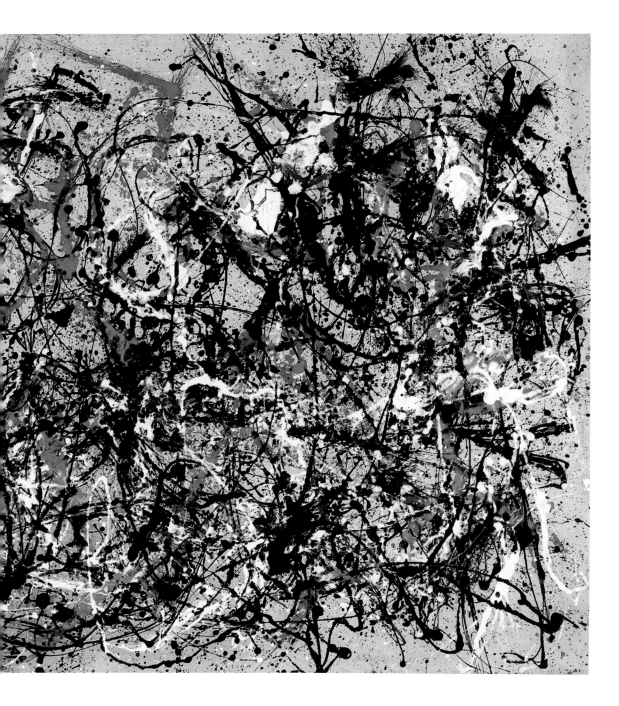

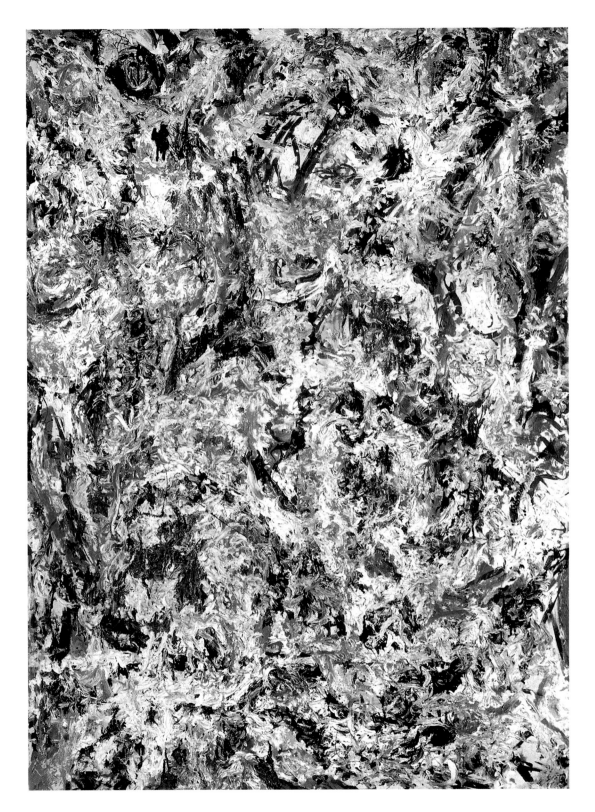

Artiste maudit or American Prometheus?

In 1951 Pollock completed a series of paintings in oil and enamel paint which became known as the *Black Paintings*. Instead of building on the complexity of a masterpiece like *Lavender Mist: Number 1, 1950* (p. 90), he returned to formal inventions already tested in works like *Gothic* (p. 55). *Number 14, 1951* (p. 82) and *Number 18, 1951* likewise seemed to contain reverberations of earlier paintings such as *Stenographic Figure* (p. 43) or drawings in the Henderson collection. Despite the fact that Greenberg again broke a lance for Pollock, the show of *Black Paintings* with Betty Parsons was anything but successful. Thinking his growing fame should gradually be reflected in increasing sales, Pollock decided in spring 1952 to leave Parsons for Sidney Janis, who persuaded him to give his pictures titles again, arguing that this would make them more accessible to viewers. Since he had done little new work, Pollock's first one-man show at the Sidney Janis Gallery in November 1952 had almost the character of a retrospective. Apart from the *Black Paintings*, it contained only two new works: *Convergence: Number 10, 1952* (pp. 88–89) and *Blue Poles: Number 11, 1952.*

Convergence differs from the works of summer 1950 above all in terms of palette, a range of colors that verges on the vulgar. Even by comparison with works that are a far cry from the colorational or compositional asceticism of *Number 32, 1950*, *Convergence* exudes a sort of delirium whose violence goes hand in hand with recklessness and a lack of concentration.

Pollock returned to the lyrical, dancing insouciance of *Mural* and *Summertime* in *Number 1, 1952* (pp. 86–87), done before his switch to Sidney Janis. Here the black configurations inscribed over a finely articulated swarm of white brushstrokes still have something of the sureness of linear sweep that characterized Pollock's earlier large-format works. Yet while these were related to each other and formed series, now Pollock began to produce individual works which often related to certain earlier ones. This testing of the viability of earlier results was accompanied by a change of technique. Pollock gave up painting on the floor and returned to the easel and the brush. In *Portrait and a Dream*, 1953 (pp. 84–85), he mixed the two techniques, combining dripped and poured passages with brushed passages. Although this must be called one of the weaker of Pollock's late works, *The Deep* (p. 83) and *Untitled* (*Scent;* p. 80) deserve attention in several respects. *The Deep* stands completely alone in Pollock's œuvre. The tendency seen here to nearly unify the white areas in order to increase the contrast

"The New Soft Look", 1951
Photographed during Pollock's exhibition at the Betty Parsons Gallery
Photograph by Cecil Beaton
Courtesy *Vogue*. Copyright © 1951 (renewed 1979) Condé Nast Publications, Inc.

Untitled (Scent), c. 1953–1955
Oil and enamel on canvas, 99 x 146 cm
Los Angeles, CA, Collection David Geffen

with the black area, like an open wound, runs counter to his earlier practice of setting the entire picture plane in rhythmical vibration. The dark, extended oval form has naturally fueled speculation regarding associations with a vagina and what these might imply.

Scent is one of Pollock's last works, the sole result of twenty months of sporadic activity. The fine articulation of the brushwork and the use of white prevent the variegated coloration from slipping into garishness. The encrusted surface is extremely vital in effect. *Scent* is a powerful, tension-filled painting in which Pollock's empathetic understanding of nature expressed itself one last time. His animism and pantheism suffuse a work that once more addresses a dream of painting that had been cherished since Kandinsky – that of a synaesthesia in which visual stimuli would be capable of activating other sense organs and forming the initial building block in a total work of art, a Gesamtkunstwerk.

In retrospect, the years 1951 to 1956, the year of Pollock's death, were years of decline. His production sank. He survived several drunk-driving accidents (the cars didn't) and submitted to several dubious treatments for alcholism. His marriage to Lee Krasner, whose increasing success as an artist negatively affected his own productivity, had deteriorated to the point that Pollock began to escape into affairs with other women. Yet at the same time, his public reputation grew apace. His works were shown in Paris, Zurich, Düsseldorf, Helsinki and Oslo. In 1950 he participated in the Venice Biennale, and the Museum of Modern Art planned his first retrospective for 1956. By 1959 at the latest, when his work appeared at Documenta II in Kassel, Pollock's reputation as the most significant representative of Abstract Expressionism in America was unassailably established.

This triumph rested above all on the unquestionable power of the masterpieces of the late 1940s. There can be no doubt that these works took the possibilities of Abstract Expressionism to an extreme, and that Pollock's huge formats

The Deep, 1953
Oil and enamel on canvas, 220.4 x 150.2 cm
Paris, Musée National d'Art Moderne, Centre Georges Pompidou

Number 14, 1951, 1951
Enamel on canvas , 146.4 x 269.2 cm
London, Tate Gallery

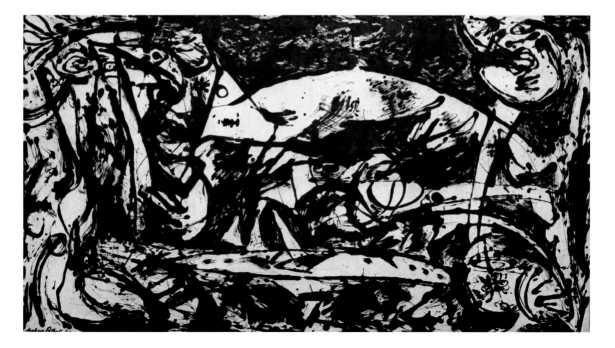

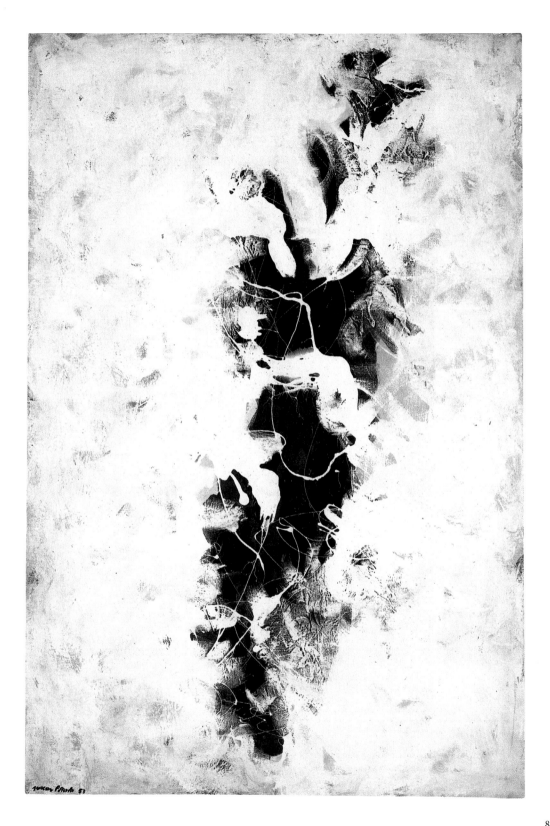

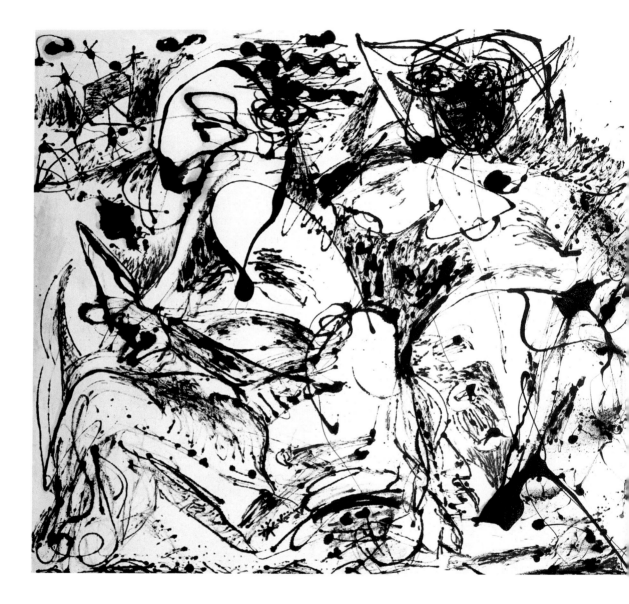

84

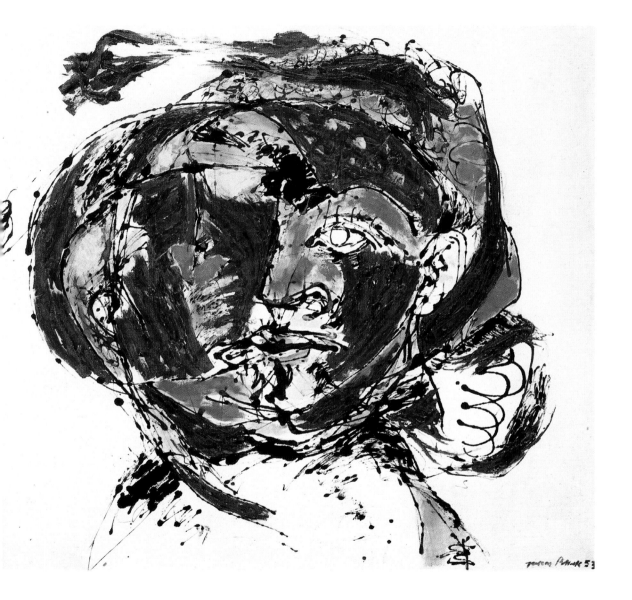

Portrait and a Dream, 1953
Oil on canvas, 148.6 x 342.2 cm
Dallas, TX, Dallas Museum of Art.
Gift of Mr. and Mrs. Algur H. Meadows
and the Meadows Foundation, Inc.

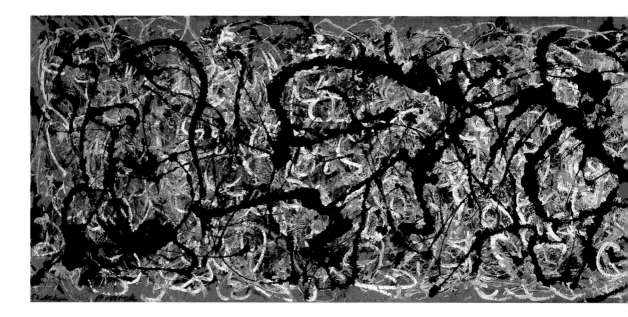

Number 1, 1952, 1952
Oil and enamel on canvas, 66 x 269.2 cm
Private collection. Courtesy C & M Arts,
New York

offered a compelling chance for viewers to experience for themselves what he meant by "being in the image."

At the same time, Pollock was the probably first artist in history to be surrounded by a myth that was largely a product of the mass media. He was the first American artist to conform to the type of the artiste maudit – his fragile, difficult personality provided an ideal opportunity to revive the image, in the air since the Romantic era, of the genius beset by mental turbulence. The construction of this myth began by associating him with the prototype Westerner, the cowboy. Pollock behind the wheel of his Model A Ford, Pollock posing in front of *Summertime* for *Life* magazine in August 1949 (p. 87), arms crossed over his chest, head tilted, the inevitable cigarette dangling from the corner of his mouth, looking out at the viewer skeptically and, perhaps, with unveiled disdain. Such photographs gave Pollock a place in that corner of the collective visual memory occupied by images of the young rebels James Dean and Marlon Brando, who revolted against American mediocrity in the 1940s and 1950s and simultaneously represented the primal American myth.

The photos taken by Hans Namuth, showing Jackson Pollock at various phases of making a painting, contributed materially to this mythopoesis. Pictures of a man with furrowed brow, meditating how to proceed; pictures of a man moving with the grace and physical strength of dancer or the out-of-self concentration of a shaman, around the picture field and slinging paint on the canvas.

We should not forget that the success of these photographs and the art whose emergence they documented was due in part to an instrumentalization of abstraction in the U.S and Western Europe at that period. Abstraction was declared the art of the Free World, in opposition to the Socialist Realism of the Eastern Bloc. Just as Willi Baumeister (1889–1955) and Fritz Winter (1905–1976) were appropriated as artists of the Adenauer period, Pollock figured as a prime representative of a Western art that permitted freedom of individual expression, in contrast to the regimented, party-line art practiced behind the Iron Curtain.

PAGES 88–89:
Convergence: Number 10, 1952, 1952
Oil and enamel on canvas, 237.49 x 393.7 cm
Buffallo, NY, Albright-Knox Art Gallery. Gift
of Seymour H. Knox, Jr., 1956 K1965:7

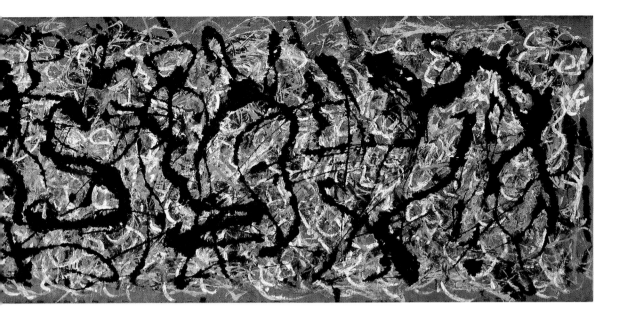

The erstwhile advocacy of Marxist ideals by Abstract Expressionist artists was hushed up.

Pollock's transgressions of conventional borderlines doubtless opened great liberties to contemporary art. Robert Morris's (b. 1931) works employing flexible, plastic materials or Richard Serra's (b. 1939) pieces in scattered molten lead can be traced directly back to Pollock. The all-over principle informs the non-relational paintings and installations of anti-expressive artists like Frank Stella (b. 1936) and the floor installations of Carl Andre (b. 1935).

Even the generation of Pop artists involved Pollock, if with ironic intent. Claes Oldenburg's (b. 1929) *Bedroom Ensemble*, 1963, featured a design inspired by Pollock's *Pouring*. Roy Lichtenstein (b. 1923) took the rapid gestural brushstroke ad absurdum by rendering it in a comic-strip manner – the gesture of unalloyed individuality and subjectivity, the very touchstone of Abstract Expressionism, quoted as an unemotional, endlessly reproducible mass media product. Pollock's method, his abandonment of the safeties of premeditated composition and acceptance of the existential risk of action, his battle in the arena of painting, is given an ironic twist in Lichtenstein's *Compositions*, the enlarged cover of a school notebook. Its all-over, Pollock-like pattern, in conjunction with the label "Compositions," sets up a dialogue in which each element exposes the other to the light of irony.

Space precludes us from discussing the reception of various aspects of Pollock's painting by artists as diverse as Lynda Benglis, Eva Hesse, Yves Klein, Brice Marden, Julian Schnabel and Robert Smithson. Suffice it to mention only two approaches that illustrate the extent to which Pollock, as the embodiment of the modern artist, is still of interest today. For his piece called *Barn*, the German photographer Thomas Demand (b. 1964) built a paper model of Pollock's studio-barn and made photographs of it. There could hardly be a method more alien to Demand than Pollock's expressive gesturalism, or to Andreas Gursky (b. 1955), whose *O.T. VI*, 1997, quotes Pollock's *One: Number 31, 1950*. Yet still, these two artists' conceptual photography accepts Pollock's approach as a deter-

Pollock in front of his painting *Summertime*, 1948
Photograph for the article "Jackson Pollock"
LIFE 8/8/49
© 1949 TIME Inc. reprinted by permission
Photograph by © Arnold Newman / Getty Images

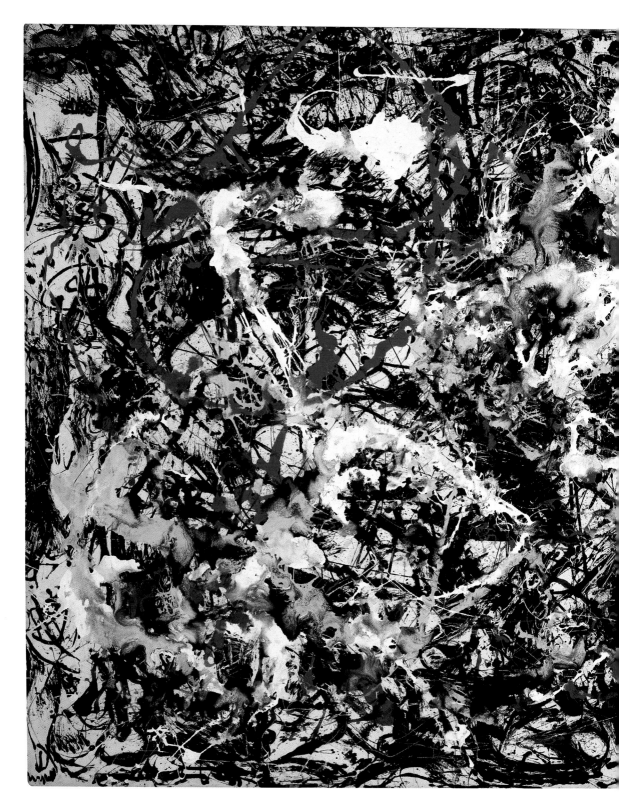

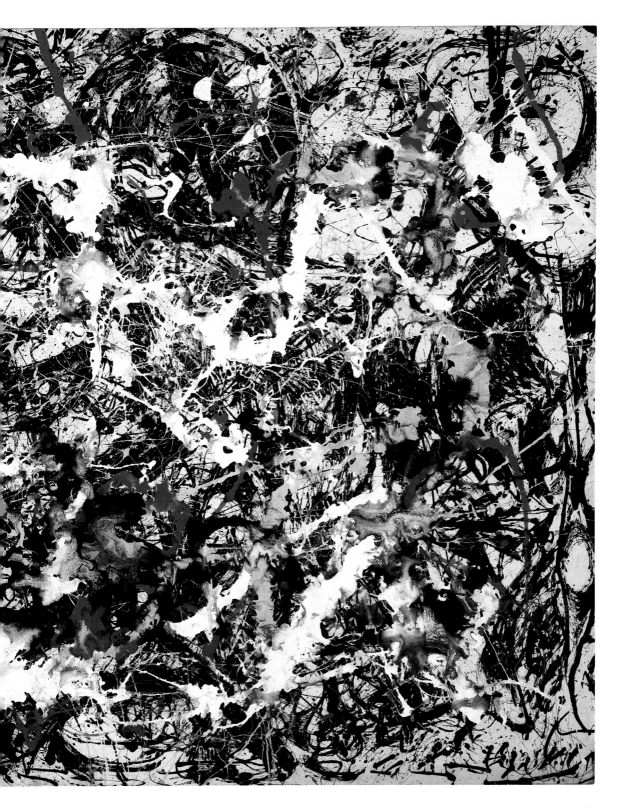

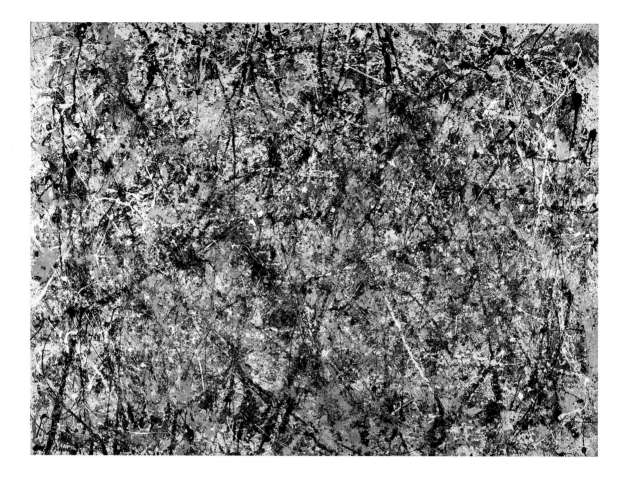

Lavender Mist: Number 1, 1950, 1950
Oil, enamel and aluminum on canvas, 221 x 299.7 cm
Washington, DC, National Gallery of Art.
Ailsa Mellon Bruce Fund

Lavender Mist: Number 1 is doubtless one of Pollock's master-
pieces, a work unsurpassed in terms of linear complexity,
energy-charged suspense, and coloristic brilliance. It attests to
the productivity of the phase from 1947 to 1951, when Pollock
was working at the height of his powers.

minant, art-historically significant stance, if one diametrically opposed to their own, and by so doing confirms its rank.

Seeing that his biography provides ideal movie material, it is surprising that the first feature film on Pollock's life, by Ed Harris, did not appear in the cinemas until 2002. The result is not only very knowledgeable but resists every temptation to raise its protagonist to the heroic status of a genius who tragically failed. The film keeps quite faithfully to the established facts, nor does it avoid the more unpleasant facets either of Pollock's personality or of that of the people around him.

The degree to which his œuvre was welcome prey for trivialization is indicated by the fashion photos Cecil Beaton took for *Vogue* in 1951 (p. 81), in which he posed models in front of works such as *Autumn Rhythm*. Something about Pollock's paintings apparently was thought suitable to underscore the elegance of these women and the fashions they wore. In addition, his art represented a token of the connoisseurship and taste of both photographer and client.

Another form of trivialization is seen in the famous Pollock dress designed by Mike Bidlo in 1982 (p. 91). Yet rather than being an ironic stab like Oldenburg's *Bedroom Ensemble*, the dress amounts to a homage on the part of a representative of the then emergent experimental gallery scene in New York's East Village, reverence accorded to a great rebel of the past.

More than that of almost any other artist, Pollock's œuvre shaped the definition and understanding of art in the latter half of the twentieth century. It marked an extreme level of subjectivity and a challenge to conventional views of what painting should or could be. It is no coincidence that representatives of the major streams in art in the wake of Abstract Expressionism continually sought solid points of anchorage – whether in figuration as a regulative, or else in a conceptualism that embedded and defined each individual result in terms of some overall strategy.

Pollock himself must have sensed that he was pushing the limits of what still could be understood as painting. One day, curious about Lee Krasner's opinion of a picture, he did not ask whether she thought it was a good painting or a bad one. He simply asked, "Is this a painting?"

Gracie Mansion wearing Mike Bidlo's *Jackson Pollock Dress*, 1982
Photograph by Gary Azon

Jackson Pollock 1912–1956
Chronology

1912 January 28: Paul Jackson Pollock is born in Cody, Wyoming. He is the fifth son of Stella May McClure and LeRoy Pollock. November: The Pollocks leave Cody and move to National City, California, near San Diego – the first in a long series of moves.

1913–1928 The Pollocks have eight different places of residence in California.

1921 Jackson's older brother, Charles, goes to Los Angeles and takes a job with the *Los Angeles Times.*

1922 Charles begins regularly sending home issues of *The Dial*, an art magazine from which Jackson gains first knowledge of modern art.

1926 In New York, Jackson enrolls at the Art Students League and enters the painting class of Thomas Hart Benton.

1927 Jackson and his brother Sanford ("Sande") work as assistants to land surveyors in the Grand Canyon (p. 92 below right). Jackson has first experiences with alcohol. Autumn: In a drunken state, Jackson becomes involved in an altercation with an officer of the Reserve Officers' Training Corps (ROTC) and is expelled from school.

1928 Stella moves with the children to Los Angeles. LeRoy remains in Riverside, while their son Frank moves to New York. At Manual Arts High School, Jackson attends the class of Frederick John de St. Vrain Schwankovsky, who introduces him to abstract art and the theosophical teachings of Krishnamurti and Rudolf Steiner. Jackson is looked upon as an outsider and cultivates dandyish attire (p. 92 below left).

1929 Expelled from Manual Arts High School. Jackson visits his father in Santa Ynez, California, but the stay ends with a fight between father and son. Reaccepted into Manual Arts. In the journal *Creative Art*, Jackson sees reproductions of the work of Diego Rivera.

1930 He is expelled from school once again. With his brothers Charles and Frank, Jackson visits Pomona College in Claremont, California, to view the mural *Prometheus* by José Clemente Orozco. September: Follows his brothers to New York, where he first attends the sculpture class of Ahron Ben-Schmuel at Greenwich House, then Thomas Hart Benton's painting class at the Art Students League. November: Orozco begins a mural in the cafeteria of the New School for Social Research, at 66 West Twelfth Street.

PAGE 92 LEFT:
Jackson Pollock as a student at Manual Arts High School, Los Angeles, 1928
Photograph by Lee Ewing. © Archives of American Art, Smithsonian Institution

PAGE 92 CENTER:
Jackson Pollock in South California, c. 1927/28
Photograph by Lee Ewing. © Archives of American Art, Smithsonian Institution

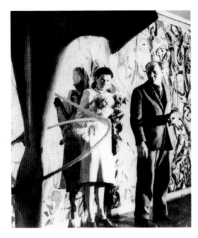

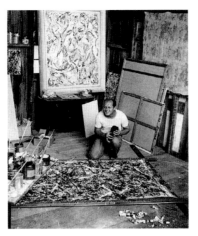

1931 Summer: Jackson hitchhikes with his friend Manuel Tolegian to Los Angeles, where he meets his old school friends Philip Guston and Reuben Kadish. Autumn: Transfers to Benton's mural class, and receives private tutoring from Benton on the side. He behaves insultingly and occasionally violently towards women, but also towards friends like Tolegian.

1932 Summer: Jackson returns to Los Angeles again, where he meets David Alfaro Siqueiros, another Mexican muralist. After returning to New York, he moves in with his brother Charles and his wife Elizabeth, in their apartment on Carmine Street. December: Benton leaves New York.

1933 Jackson attends various classes in drawing and sculpture. March 6: His father dies. Jackson moves with Charles and Elizabeth into an apartment at 46 East Eighth Street. He watches Diego Rivera painting a mural for the RCA Building in Rockefeller Center, which will soon be destroyed as communist propaganda. Autumn: Jackson moves into an apartment on Fifty-Eighth Street and attempts to manage on his own.

1934 Visits the Bentons at their country house in Childmark on Martha's

Vineyard, Massachusetts. He will spend summer vacations here until 1937. With Charles, Jackson takes his fourth trip in five years to the Western states. October: Jackson moves with his brother Sande into an apartment on Houston Street. Earns money doing cleaning work at the City and Country School.

1935 Employed on a program for the restoration of public monuments. Benton leaves New York and goes to Kansas City. Jackson and Sande enroll in a mural class sponsored by the Federal Arts Project of President Roosevelt's Works Progress Administration (WPA).

1936 Jackson participates in Siqueiros's workshop "Laboratory of Modern Techniques in Art" (p. 93 below). After Sande weds Arloie Conaway, the three share an apartment on Eighth Street. With Sande and Philip Guston, Jackson goes to Dartmouth College, Hanover, New Hampshire, to see Orozco's mural *The Epic of American Civilization*.

1937 At Sande's insistence, Jackson begins therapy. A watercolor of his is exhibited in the WPA Gallery. Winter: Travels to Kansas to visit Benton, and visits his brother Charles in Detroit, where Charles works as an illustrator.

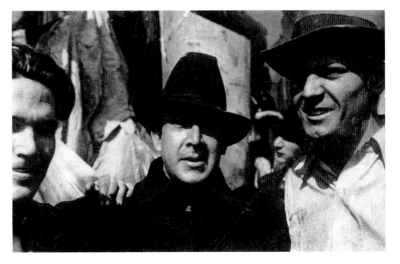

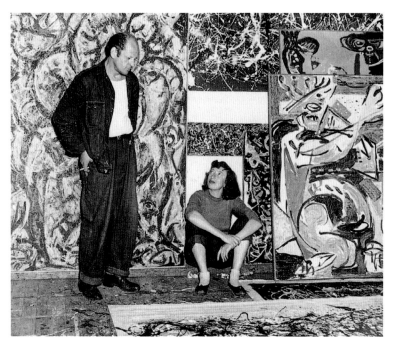

PAGE 94 ABOVE:
Jackson Pollock and Lee Krasner in the studio, 1949
Photograph by Lawrence Larkin. © Archives of American Art, Smithsonian Institution

PAGE 94 BELOW:
Jackson Pollock, 1953
Photograph by Tony Vaccaro

PAGE 95:
"The Irascibles" from 1950, published in *Life*, January 15, 1951
Photograph by Nina Leen / *Life Magazine*
© Time Life Pictures / Getty Images

1938 Due to continual absence Jackson is dropped from the WPA rolls. July–September: He undertakes therapy for alcoholism at Bloomingdale Asylum, White Plains, New York.

1939 Begins psychotherapy with Dr. Joseph L. Henderson, an adherent of the theories of Carl Gustav Jung. To faciliate therapy he brings drawings and sketches to the sessions. May: Sees Picasso's *Guernica* at the Valentine Gallery.

1940 Jackson looks on as Orozco executes a painting at the Museum of Modern Art, for the exhibition "Twenty Centuries of Mexican Art." After Dr. Henderson leaves New York, Jackson continues therapy with Dr. Violet Staub de Laszlo.

1941 Jackson visits the exhibition "Indian Art of the United States" at the Museum of Modern Art, and watches Navajo artists making sand paintings on the museum floor. Becomes acquainted with Lee Krasner.

1942 First participation in an important exhibition, "American and French Painting," where works by Lee Krasner are also on view. August: She moves into the apartment with him on Eighth Street, after Sande and his wife have gone to Deep River, Connecticut. Krasner obtains various jobs for Pollock with the WPA. At the end of the year, he works as a roller cleaner in a printing shop. Terminates his therapy with de Laszlo.

1943 Jackson Pollock is employed as an attendant at the Museum of Non-Objective Painting. Piet Mondrian persuades Peggy Guggenheim to in-

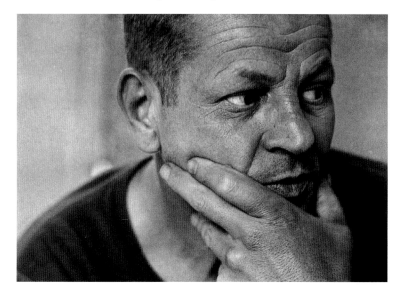

clude *Stenographic Figure* in the "Spring Salon for Young Artists" at her gallery, Art of This Century. Subsequently she gives Pollock his first one-man show there. At the end of the year, he paints *Mural* for Guggenheim's house on East Sixty-First Street (p. 93 above left).

1944 The Museum of Modern Art acquires *The She-Wolf.* Summer: Krasner and Pollock vacation in Provincetown, Massachusetts. Autumn: Pollock begins making etchings at Stanley William Hayter's Atelier 17. Krasner persuades Pollock to take homeopathic therapy for his drinking problem. Sidney Janis publishes *The She-Wolf* in his book *Abstract and Surrealist Art in America.*

1945 October 25: Lee Krasner and Jackson Pollock are married. November 11: They move to The Springs, East Hampton, Long Island.

1946 First participation in the "Annual Exhibition of Contemporary American Painting" at the Whitney Museum.

1947 Inception of the drip paintings. Fourth and final one-man show at Art of This Century. Peggy Guggenheim decides to return to Europe. *Mural* is shown in the exhibition "Large Scale Modern Paintings" at the Museum of Modern Art. Pollock's *Galaxy* is included in the Whitney Annual.

1948 First solo exhibition with Betty Parsons. Peggy Guggenheim's collection, including six Pollock paintings, is shown at the Venice Biennale. Friendship with Tony Smith begins. Pollock is successfully treated for alcholism by Dr. Edwin Heller.

1949 Makes the acquaintance of Alfonso Ossorio. August 8: An article is published in *Life* magazine under the title "Jackson Pollock: Is he the great-

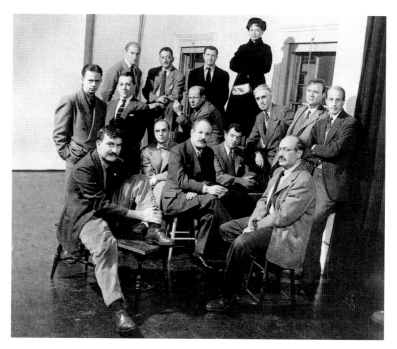

est living painter in the United States?" Pollock shows a painting in the exhibition "The Intrasubjectives," at Samuel Kootz Gallery, New York. This exhibition, which includes works by Arshile Gorky, Willem de Kooning, Robert Motherwell, Ad Reinhard, Mark Rothko et al., contributes decisively to the formation of the Abstract Expressionist movement. Pollock shows *Number 14, 1949* in the Whitney Annual.

1950 The Museum of Modern Art purchases *Number 1 A, 1948.* Death of Edwin Heller in an automobile accident. Pollock joins a protest against the exhibition policies of the Metropolitan Museum of Art. Participates in the Venice Biennale. Collaborates with Alfonso Ossorio and Tony Smith on plans for the construction and decoration of a Catholic church on Long Island, which, however, do not come to fruition. July and August: Hans Namuth photographs Pollock at work. Solo exhibition of works from the Guggenheim Collection at Museo Correr, Venice. Represented in "Young

Painters in the U.S. & France," curated by Leo Castelli and held at Sidney Janis Gallery, New York. Pollock shows *Number 3, 1950* in the Whitney Annual. Namuth finishes his film on Pollock's working procedure. Jackson Pollock suddenly relapses into excessive drinking.

1951 *Life* carries a photo of the "Irascibles," a group of artists who vent their disapproval of the Metropolitan Museum's exhibition policy. *Vogue* publishes fashion photos by Cecil Beaton in which Pollock paintings appear in the background (p. 81). He participates in the exhibition "Abstract Painting and Sculpture in America" at the Museum of Modern Art. Michel Tapié shows *Number 8, 1950* at Galerie Dausset, Paris. Namuth's film premiers at the Museum of Modern Art.

1952 Ossorio organizes an exhibition at Studio Facchetti, Paris. Pollock is included in the exhibition "15 Americans" at the Museum of Modern Art. May: Moves to Sidney Janis Gallery,

followed by his first one-man show there. "A Retrospective Show of the Paintings of Jackson Pollock," curated by Clement Greenberg, is held at Bennington College, Bennington, Vermont.

1953 Represented at the exhibition "12 Peintres et Sculpteurs Américains Contemporains" at the Musée national d'art moderne, Paris. The exhibition travels to Zurich, Düsseldorf, Stockholm, Helsinki and Oslo. Pollock shows *Number 5, 1952* at the Whitney Annual.

1954 Pollock ceases almost entirely to paint. Second one-man show with Sidney Janis.

1955 Autumn: Lee Krasner has solo show at the Stable Gallery. Pollock's third one-man show with Sidney Janis. Since few recent works are available, the show has the character of a retrospective.

1956 Pollock has painted nothing for eighteen months, and has gained a great deal of weight. May: Hears that the Museum of Modern Art is plan-

ning a retrospective of his works. July: Lee Krasner flies to Europe. During her absence, Ruth Kligman, a young New York artist, moves in with Pollock at The Springs. August 11: Drunk at the wheel, he loses control of his car, crashes into a tree and dies. With him dies Edith Metzger, a girlfriend of Kligman, who survives the accident seriously injured. The planned exhibition at the Museum of Modern Art is shown as a memorial exhibition, from December 19, 1956 to February 3, 1957.

Bibliography

Claude Cernuschi, *Jackson Pollock: Psychoanalytic Drawings,* London, 1992

Claude Cernuschi, *Jackson Pollock, Meaning and Significance,* New York, 1993

Ellen Frank, *Jackson Pollock,* New York, 1983

Pepe Karmel, *Jackson Pollock – Interviews, Articles and Reviews,* New York, 1998

Ellen G. Landau, *Jackson Pollock,* New York, 1989

Jeremy Lewinson, *Interpreting Pollock,* London, 1999

Hans Namuth, *L'atelier de Jackson Pollock,* Paris, 1978

Steven W. Naifeh, Gregory White Smith, *Jackson Pollock – An American Saga,* London, 1991

Jackson Pollock. Catalogue Raisonné of Paintings, Drawings and other Works, 4 vols., Yale University Press, 1978

Jackson Pollock, Zeichnungen, exh. cat. Württembergischer Kunstverein, Stuttgart, 1990

Regine Prange, *Jackson Pollock, Number 32, 1950 – Malerei als Gegenwart,* Frankfurt a. M., 1996

Kirk Varnedoe, Pepe Karmel, *Jackson Pollock,* exh. cat. The Museum of Modern Art, New York, 1998 / Tate Gallery, London, 1999

Photo Credits

The publisher wish to thank the museums, private collections, archives, galleries and photographers who granted permission to reproduce works and gave support in the making of the book. In addition to the collections and museums named in the picture captions, we wish to credit the following:

© Archiv für Kunst und Geschichte, Berlin: pp. 8/9, 24, 36/37, 56/57, 67, 82, 83, 94 below; © Archives of American Art, Smithsonian Institution, Washington, DC: pp. 7, 92, 93 above right, 93 below, 94 above; ARTOTHEK: pp. 15, 16, 18, 21, 84/85, 90; Photograph © Gary Azon:

p. 91; Cecil Beaton / *Vogue* © Condé Nast Publications Inc.: p. 81; © Hirshhorn Museum and Sculpture Garden, Smithsonian Institution, Washington, DC, Photograph by Lee Stalsworth: p. 62; Photo: Walter Klein: p. 76; Photograph © 1980 The Metropolitan Museum of Art, New York: p. 12; Photograph © 1985 The Metropolitan Museum of Art, New York: pp. 78/79; Photograph © 1998 The Metropolitan Museum of Art, New York: pp. 40/41, 70; Photograph © 2002 The Metropolitan Museum of Art, New York: p. 28 above right; Digital Image © The Museum of Modern Art, New York / Scala, Florence: front cover, pp. 11, 31 above, 31 below, 42, 43, 52/53, 55,

59, 60 above, 63, 64, 77; © Hans Namuth Ltd., New York: back cover, pp. 65, 74/75; Photo: Horstheinz Neuendorff, Baden-Baden: p. 50; New Britain Museum of Art, Photo credit: E. Irving Blomstrann: p. 13; © Arnold Newman / Getty Images: pp. 2, 87; Photograph © 2003 The Solomon R. Guggenheim Foundation, New York: pp. 35, 58 (David Heald), 93 left; © Tate, London 2003: pp. 20, 68/69; © Time Life Pictures / Getty Images: p. 95; © Virginia Museum of Art, Richmond, Photo: Ron Jennings: p. 73 above; Courtesy Joan T. Washburn Gallery, New York: pp. 1, 19.